IMAGES
of America

ARCHITECTURE OF
MINNEAPOLIS PARKS

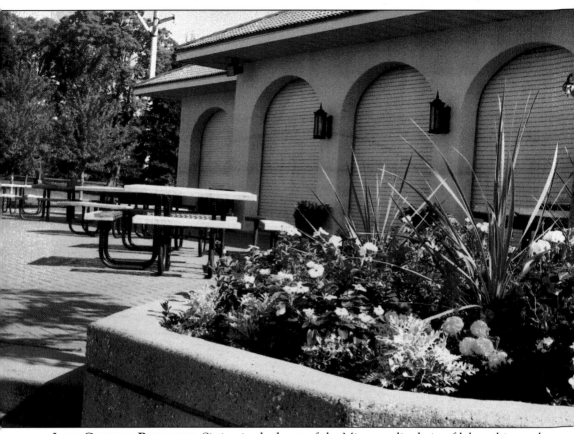

LAKE CALHOUN REFECTORY. Sitting in the heart of the Minneapolis chain of lakes, this nearly 100-year-old structure serves ice cream and other refreshments to bicyclists, runners, skaters, and anyone else. If a person turns around after buying goodies, the open arches frame a magnificent view across Lake Calhoun.

ON THE COVER: **THOMAS LOWRY PARK.** The brick colonnade that graces the cover of this book does the same for the Lowry Hill neighborhood in Minneapolis. This small parcel of land provides a quiet serenity that enhances the elegant houses on its surrounding streets.

IMAGES
of America

ARCHITECTURE OF MINNEAPOLIS PARKS

Albert D. Wittman

ARCADIA
PUBLISHING

Copyright © 2010 by Albert D. Wittman
ISBN 978-0-7385-6026-7

Published by Arcadia Publishing
Charleston SC, Chicago IL, Portsmouth NH, San Francisco CA

Printed in the United States of America

Library of Congress Control Number: 2009937346

For all general information contact Arcadia Publishing at:
Telephone 843-853-2070
Fax 843-853-0044
E-mail sales@arcadiapublishing.com
For customer service and orders:
Toll-Free 1-888-313-2665

Visit us on the Internet at www.arcadiapublishing.com

CONTENTS

ACKNOWLEDGMENTS

The authors with published books listed in the bibliography made the preparation of this book substantially more efficient. I would like to thank the Minneapolis Central Library, James K. Hosmer Special Collection, and the Minneapolis collection, from which copies of the historical photographs of the Hennepin Avenue bridges were obtained. Thank you to the Minneapolis Central Library, James K. Hosmer Special Collections staff (especially Natalie Hart), who went out of their way to help find material. Thank you to MaryLynn Pulscher of the Minneapolis Park and Recreation Board staff for finding many of her own photographs and those of the early park buildings. Thank you to John A. Wittman for photography work and assistance in assembling photographs and text. To the Minneapolis Park and Recreation Board, formerly known as the Minneapolis Board of Park Commissioners, for creating an outstanding park and recreation system.

In the text, "Park Board" refers to: Minneapolis Board of Park Commissioners, 1883–June 30, 1969; Minneapolis Park and Recreation Board, July 1, 1969–present

INTRODUCTION

Possibly no other park system in the United State has such a rich treasure of architecture within its boundaries as the one in Minneapolis. There are both historically significant structures, such as the John H. Stevens House, and recent city "image makers" like the Boom Island Lighthouse and the Lake Harriet bandstand. There is also an array of recreation buildings, each with its own design.

Minneapolis park scenery is enhanced by some of the city's most significant structures, such as the castle-like Grain Belt Brewery or the postmodern new Guthrie Theater. These all sit next to parks or are in them. The city's parkways nearly encircle the city, giving almost a constantly changing view of the downtown skyline. And some of the city's finest mansions adjoin the parkways encircling the city's lakes.

Garden architecture and sculptures are in many park systems, and Minneapolis is no exception. However, Minneapolis also has its share of naval architecture in the form of the mighty tugs that ply the Mississippi.

Many of these architectural treasures are presented here. Some are old. Some are new. Some are borrowed. Some are blue. Each has its own story, briefly presented along with photographs. Unless otherwise noted, images are from the author's collection.

One

OLD TREASURES

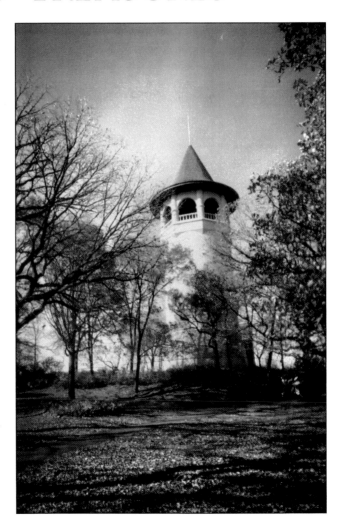

SOMETHING OLD. Some Minneapolis parks are 125 years old and still have their original buildings. Some park buildings played an important role in the early beginnings of the city, and those, as well as others, are on the National Register of Historic Places. Each park structure has a distinctive style and story. Some have been preserved and serve a different function, while others are used for their original purpose. All are on parkland.

THE ARD GODFREY HOUSE. Built in 1848, the Godfrey house is possibly the oldest standing in Minneapolis. It is located in Chute Square, a Minneapolis park named after early pioneer Richard Chute. The Godfrey house was moved several times from its original location on Main Street before it landed at Chute Square in 1909. Early settlers were able to stay temporarily with the Godfreys in this house until they got settled or moved on. Later the house was used by the Minnesota Pioneers as a museum until 1943. In the late 1970s, the Minneapolis Women's Club approached the Park Board with a proposal suggesting the women's club take the responsibility of restoring the house. By 1979, the women's club reopened the restored house to the public. Through the process, the club generated substantial interest and help from many individuals, groups, and the Minneapolis construction trades. In 1985, the Minneapolis Women's Club added the kitchen wing with a grant from the Boisclair Corporation.

BEARD'S PLAISANCE. This is the place for people who like to picnic in a grand manner. On a high knoll overlooking Lake Harriet sits this 100-year-old-plus picnic shelter. Designed by well-known Minneapolis architect Harry Jones, it sits on land donated by Henry Beard, a local developer at the time.

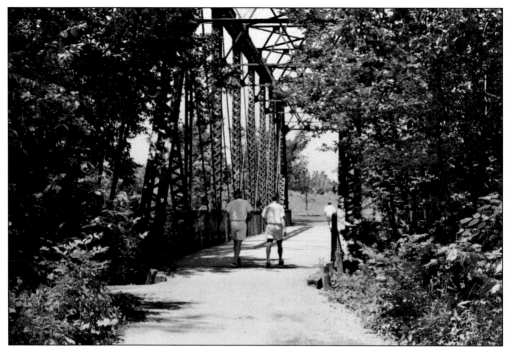

BOOM ISLAND RAILROAD BRIDGE. Dating back to the rail yard days of Boom Island, this bridge connects Nicollet Island to Boom Island by crossing the east channel of the Mississippi. The bridge became park property when the Park Board acquired Boom Island in 1982. The bridge was updated when a park official's leg went through the old decking.

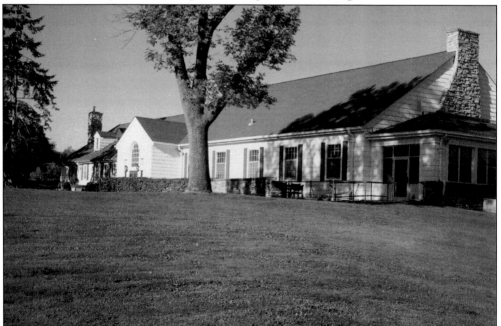

COLUMBIA PARK MANOR. This manor was built in 1925 in the Colonial Revival style, which seems to be fairly common in this era. It is a well-known fixture in northeast Minneapolis and has hosted countless wedding receptions, celebrations, and meetings, besides being a home for golfers.

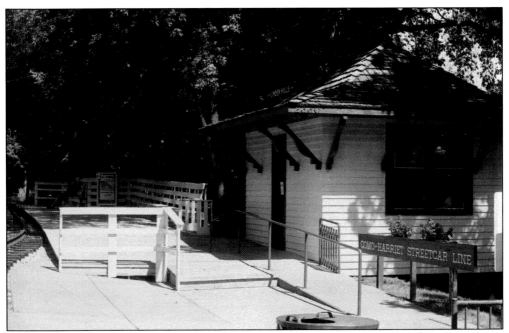

COMO-HARRIET STREETCAR LINE AND STATION. Since the late 1800s, trolleys brought people to Lake Harriet, and this service did not stop until 1954. In the early 1970s, the Minnesota Transportation Museum laid a 1-mile section of the line in the vicinity of Forty-second Street at Queen Avenue South in conjunction with restoring old 1300, one of the trolleys from the heyday of streetcars. Today the line stretches along its original route from Lake Harriet to Lake Calhoun. The station, built in 1989 by transportation museum members, is a replica of the original. In terms of style, it is typical of the many small rail stations built in the late 1800s and early 1900s.

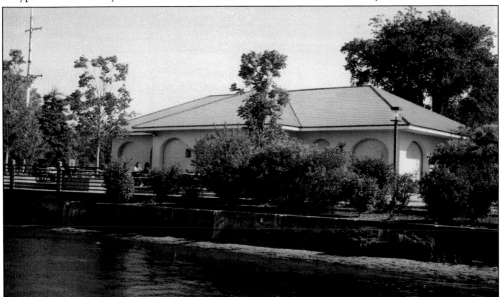

LAKE CALHOUN REFECTORY. Constructed in 1911, the Lake Calhoun Refectory is the last remaining building around the lake. Over its life, it has served refreshments and rented out canoes. Damaged by a fire in the early 1970s, it went unused until it was renovated in the late 1990s.

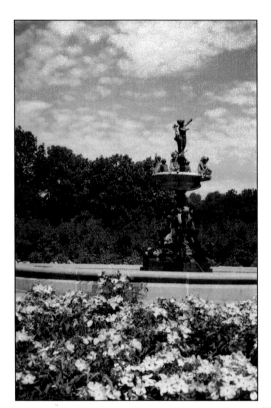

HEFFELFINGER FOUNTAIN. On September 6, 1944, the Park Board commissioners accepted Frank Heffelfinger's gift of this fountain. This bronze and marble fountain was originally in the garden of a villa near Florence, Italy. It was not actually installed in the Rose Gardens until sometime after World War II.

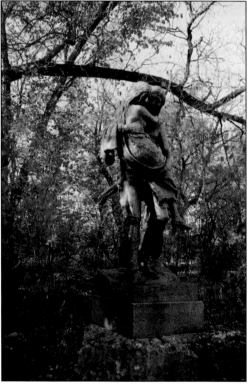

HIAWATHA AND MINNEHAHA STATUE. Originally at the Chicago World's Fair in 1893, this life-size bronze statue of Hiawatha carrying Minnehaha was purchased by the schoolchildren of Minneapolis and brought to Minnehaha Park in 1912. It is the work of sculptor Jacob Fjelde, whose grandson worked as a landscape architect for the Park Board in the late 1960s and early 1970s.

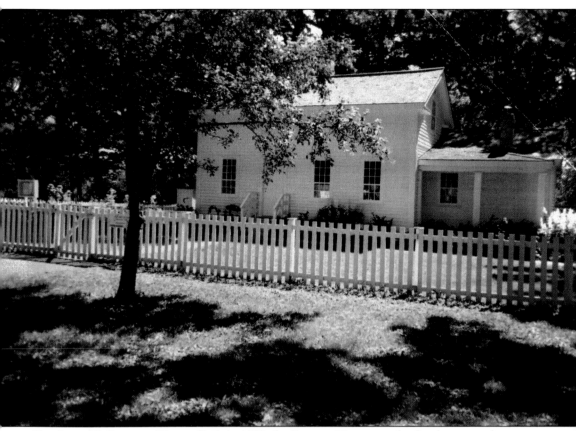

THE JOHN H. STEVENS HOUSE. Built in 1850, the Stevens House was the first house on the west bank of the Mississippi River, originally on the site near the current post office. On May 28, 1896, the house was towed to Minnehaha Park by Minneapolis schoolchildren, where the Park Board took possession. In this building, the name Minneapolis was chosen, Hennepin County and the Minneapolis School District were organized, and the idea for the state fair originated. In the 1980s, the Minneapolis Junior League decided to refurbish the house. With the help of commissioner Dale W. Gilbert, a permanent location was found within the park, and the house was towed with the assistance of another group of schoolchildren exactly 87 years to the day it was first moved. One of the original schoolchildren was on hand for the second towing. It is managed by the Friends of the John H. Stevens House Museum and a community board of directors.

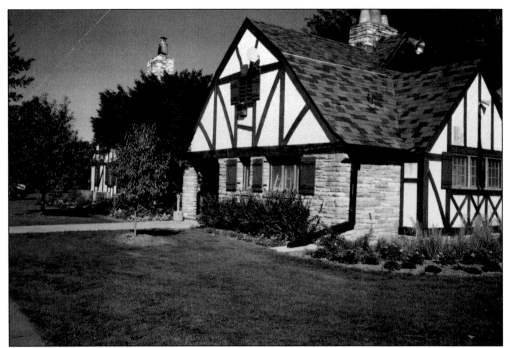

LAKE HIAWATHA GOLF COURSE AND LEARNING CENTER. Tucked away two blocks east of Cedar Avenue on East Forty-sixth Street and about two blocks north of Minnehaha Parkway is this handsome Tudor-style building, designed by Staus, Dorr, Barsback, and Chapin in the early 1930s. It is unnoticed except by the loyal fans who play the Lake Hiawatha Golf Course. The clubhouse was renovated in 1991 and now includes a golf learning center to help improve driving and putting skills and attract young golfers.

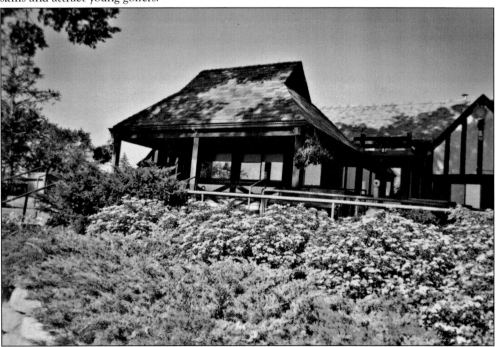

LAKE HIAWATHA RECREATION CENTER. The recreation center that overlooks Lake Hiawatha was designed in 1929 by Harry Jones, a well-recognized Minneapolis architect and park commissioner. It represents an era of one-room park centers common in Minneapolis and elsewhere. It was recently remodeled for accessibility, energy efficiency, and additional space. The renovation work did not lose the original character of the building and may have enhanced it.

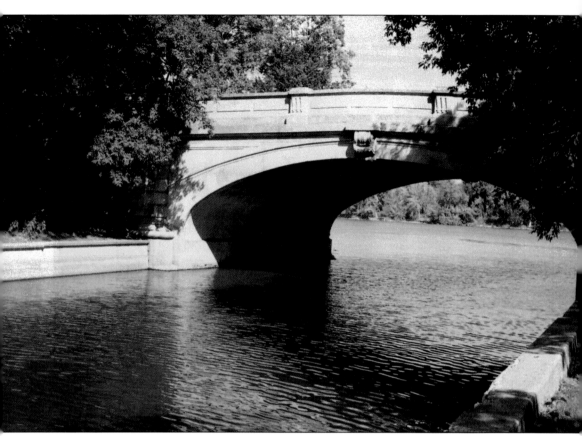

LAKE OF THE ISLES PARKWAY BRIDGE. One of the most celebrated events in Minneapolis park history was the joining of Lake Calhoun with Lake of the Isles and Lake of the Isles with Cedar Lake via excavated lagoons and channels. The highlight of a series of weeklong celebrations was on July 5, 1911; it was the grand day for joining of the lakes. More than digging had been required to make this happen. Six bridges were needed—two of which were for parkways. The Park Board commissioners held a design contest to ensure attractive, durable bridges. The winning design for the two parkway bridges was by William Pierce Cowles and Cecil Bayless Chapman of Minneapolis. These are concrete structures with limestone facing that still stand today.

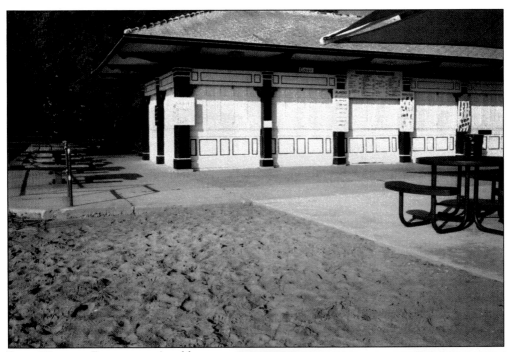

LAKE NOKOMIS REFECTORY. A golden oldie dating back to 1930, this wooden structure with an old-time amusement park flair to its architecture has served more than its share of soda pop and ice cream. The sign on the left corner reads, "No shirt, No shoes, No problem." What more can be said?

LAKE HIAWATHA SERVICE CENTER. The Park Board has four maintenance centers; one is located in each quadrant of the city. The Lake Hiawatha Service Center serves the south-central portion. Built in 1932 on East Minnehaha Parkway near Longfellow Avenue, its entrance can hold its own with any residence on any parkway. With its outside service grounds tucked behind trees, one may never notice it.

LONGFELLOW HOUSE. The house was built in 1906 by the entrepreneur R. F. "Fish" Jones to be a two-thirds-scale replica of Longfellow's house in Cambridge, Massachusetts. Jones both resided there and used it as a headquarters for a zoo he operated on the site until 1930. It was restored by the Works Progress Administration (WPA) in 1937 and operated as a branch library for 31 years. Its historic significance is not as a replica but as the only remaining building of the Longfellow Garden and Zoo. The house was relocated within Minnehaha Park by the Minnesota Department of Transportation as the first step in expanding Trunk Highway 55. Its original location was almost directly over a planned tunnel. The structure of the house was then restored by the Park Board with the use of a state grant. The house is now handsomely furnished and used as an information and interpretive center.

THE LORING RECREATION AND ARTS CENTER. This is the oldest continuous recreation building in the Minneapolis park system. It was constructed in 1916. In the 1970s, park staff looked at replacing the building with a new structure that could function as a restaurant in the park, but local residents would not hear of it. The building was refurbished in 1977 and in 2003 was expanded to enable the creation of an arts center. The addition was designed by local firm Miller Dunwiddie.

LORING BRIDGE. Charles Loring has been labeled "the father of Minneapolis Parks." William Folwell called him Minnesota's "apostle of parks and playgrounds." Loring Park, the closest Minneapolis has to a central park, carries his name. Loring was the first president of the Park Board commissioners. The Loring Bridge is believed to have been built in the late 1800s or early 1900s.

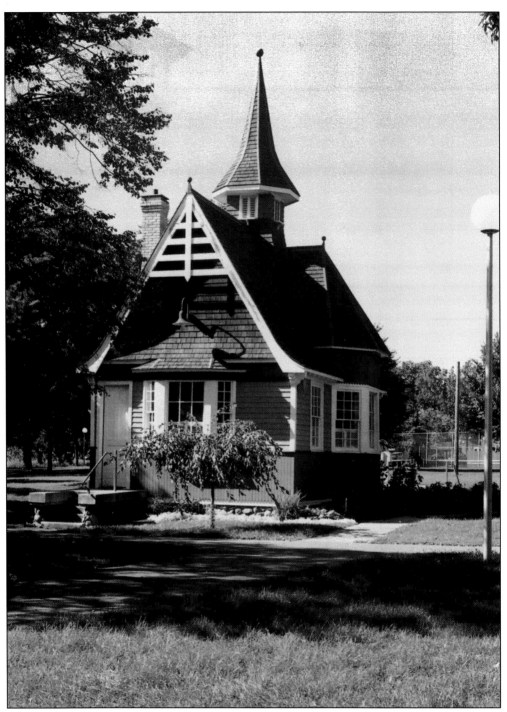

FIRST SUPERINTENDENT'S OFFICE. This little building with a Victorian flair long sat in Loring Park adjacent to Fifteenth Street. Built in 1889, it has had other uses, among which was a privately operated sandwich shop in the late 1970s and early 1980s. When major renovation work for Loring Park occurred in the late 1990s, the building was moved to the interior of the park as a backdrop for an ornamental garden.

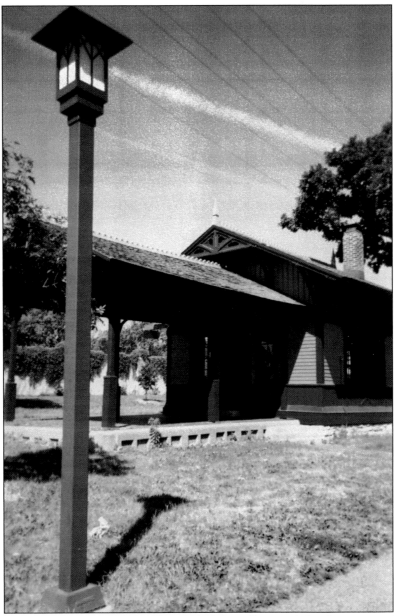

MINNEHAHA PARK—PRINCESS STATION (DEPOT). Originally intended to be a state park, the area encompassing Minnehaha Falls was acquired in 1899 by the Park Board commissioners when the state was financially unable to do so. However, long before it became a park people were coming, largely by rail, to see the falls. In about 1875, this little station was constructed. By the early 1900s, thirty-nine trains a day were carrying people to relax and picnic at the area. The last train the author saw here was a Wisconsin Central streamlined excursion train in the mid-1990s. In 1976, the Freedom Train stopped here for the Minneapolis bicentennial celebration. The station is typical of small rail stations of its time. It was dubbed the "Little Princess" by Milwaukee Road train crews. Built by the Milwaukee Road, it is now owned by the Minnesota Historic Society and maintained by the Minnesota Transportation Museum in the Milwaukee Road colors of light orange and burgundy.

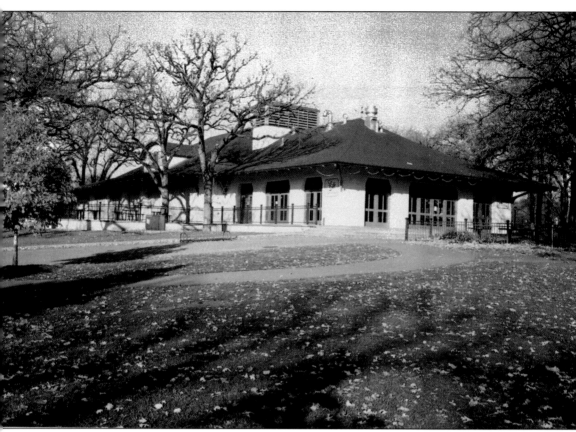

MINNEHAHA PARK PAVILION AND REFECTORY. Like a great aunt that always feeds everyone when they visit, this timeless structure, built in the early 1900s, will always see that whatever one brings to eat will be under shelter or whatever is bought at the refectory will be yummy. The pavilion sits near Minnehaha Creek just before it plunges 50 feet to the Longfellow Glen on its way to the Mississippi. This stucco and wood structure, with its copious restrooms and long array of stove-top burners for cooking or keeping food hot, was renovated in the late 1950s and again in the late 1990s. With its large roll-up doors, it protects from the worst of weather or opens to the best that Mother Nature provides. Its design, originally with a red-tile roof, has hints of the mission-style architecture of the Loring Park buildings. Its new veranda and accessible features bring it up to date. Reminiscent of a bygone era, it is the last remaining of several park structures that once stood at Minnehaha Park. (Courtesy Park Board.)

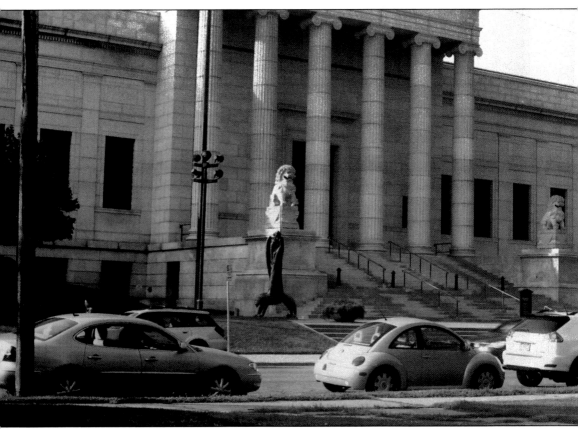

MINNEAPOLIS INSTITUTE OF ART. The institute was built in 1915 on the site of the Dorilus Morrison mansion. Morrison was the first mayor of Minneapolis and a member of its first park commission. The site is owned by the Park Board, which for many years collected the taxes that paid for the operation of the institute. In this role, the Park Board had a member sit on the institute's board. This handsome Greek-style museum was designed by McKim, Mead, and White and is typical in style of many art museums built in its era. In 1974, a major contemporary expansion was designed by Japanese architect Kenzo Tange with Parker Klein Associates acting as executive architects. The expansion included a new main entrance on Third Avenue South, and the original entrance was then closed. About 30 years later, a second addition, designed by Michael Graves in conjunction with RSP architects, was completed and the original grand entrance was reopened.

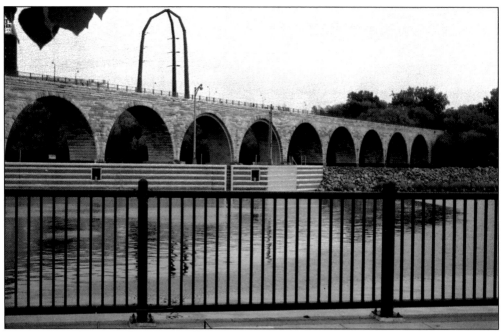

STONE ARCH BRIDGE. There are hardly any books about railroads, transportation, or Minnesota history that don't have a photograph of a train crossing this bridge. It carried some of the world's great passenger trains between Chicago and the Pacific Northwest. The Stone Arch Bridge stood unused for several years after the last train crossed it in the early 1970s. It was built in 1883 by the Great Northern Railroad and is on the National Register of Civil Engineering Structures. Its size, graceful style, and location make it a significant feature of the Minneapolis riverfront. Now one can walk or bicycle on it without benefit of a ticket; up until a few years ago, for a small price, a person could ride the River City Trolley. The Minnesota Department of Transportation now owns the bridge. The Park Board maintains its surface, and the Minnesota Historical Society conducts interpretive programs at the bridge.

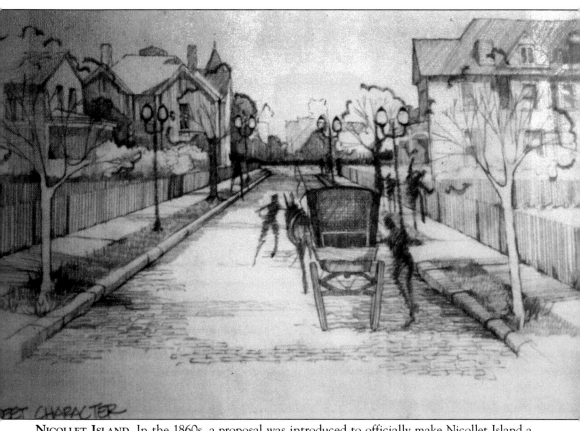

NICOLLET ISLAND. In the 1860s, a proposal was introduced to officially make Nicollet Island a park. However, the cities of Saint Anthony and Minneapolis were considering joining together, and the proposal was lost in the political shuffle. Over 100 years later, the mills were closing, and Minneapolis began planning for the area around Saint Anthony Falls. Nicollet Island became a continuous source of debate among groups. The Park Board saw it as a park, the Minneapolis Community Development Agency saw it as a development opportunity, and historic interests wanted the area preserved, all while local residents wanted to be left alone. Finally, in 1983, a proposal by Mayor Donald Fraser ended the debate. Under this proposal, the Park Board would own the land except a section that was marked for private development. The Minneapolis Housing and Redevelopment Authority (MHRA) would sell its holdings to the Park Board. In exchange, the historic houses would be leased to the MHRA for 99 years. (Courtesy Park Board.)

NICOLLET ISLAND HOUSES. The upper portion of Nicollet Island has 17 historic houses. With the exception of a replica house and a building next to the Grove Street Flats, all were built in the late 1800s. Each house was restored to meet both city codes and the Department of the Interior standards for historic preservation.

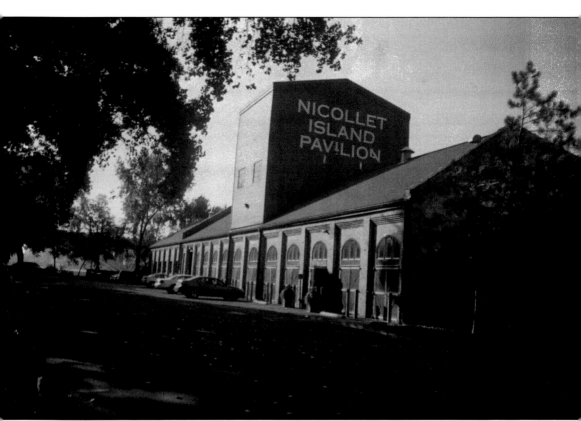

NICOLLET ISLAND PAVILION. In 1981, the Park Board acquired the lower tip of Nicollet Island, which came with the Durkee-Atwood plant, a manufacturer of rubber parts for automobiles. The plant was reminiscent of a 19th-century sweatshop. A dilemma arose on how to make an appealing park while preserving history. One of the two oldest pieces of this conglomerate had a nonsymmetrical metal truss roof structure with only a few supporting columns. With the bottom chord of the truss two stories high, it left a spacious, nearly clear, space suitable for interior park activities. Winsor Faricy Architects prepared a renovation plan with this in mind. Martin and Pitz Landscape Architects designed the adjoining site. The result was an 1893 industrial building renovated in 1986. It had large doors that swung open to the river and an outside deck so close to the Mississippi River a person might almost dangle his or her toes in it as it rushed to drop 50 feet down the apron of Saint Anthony Falls.

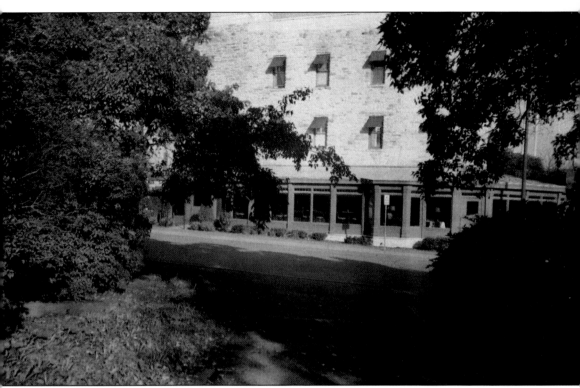

NICOLLET ISLAND INN. The Island Sash and Door Company was built in 1893 during the lumber milling days of the city. It is now a small luxury hotel with a resort-like feel. It is within the shadow of downtown while immersed in the venue of the city's early history. The Nicollet Island Inn almost completely collapsed when the Minneapolis Community Development Agency started renovation work in it in the 1980s. However, rebuilding from nearly the ground up, its renovation was accomplished. Keeping within preservation guidelines, an enclosed veranda was wrapped around the first floor for a hotel dining experience with an unmatched view of the Mississippi's east channel.

BROADWAY BRIDGE/MERRIAM STREET BRIDGE. When Hennepin County rebuilt the Broadway Bridge, it committed to the Minnesota Historical Society to keep at least one section of the old bridge for historic preservation. This Pratt truss span, built in 1887 by the King Iron Company, fit perfectly across the east channel of the Mississippi, extending Merriam Street from Nicollet Island to Main Street. It made a much-needed pedestrian, bicycle, and automobile connection for park users. Brought downriver from Broadway Street in 1982 between two towboats, it appeared on several local television news shows.

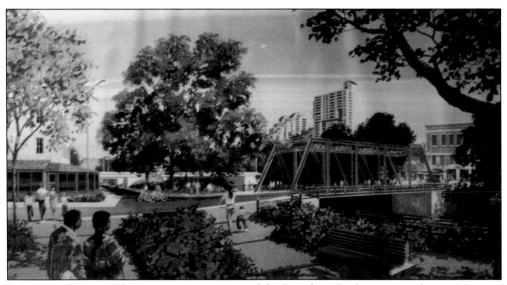

BROADWAY BRIDGE. This is an artist's concept of the Broadway Bridge span in place at Merriam Street between Main Street and Nicollet Island.

PARK SUPERINTENDENT'S HOUSE. It is doubtful that Lowell Lamoreaux, the architect, thought his work would be in the National Register of Historic Places. Built in 1910, the house was part of the compensation package to Theodore Wirth as park superintendent. The five-story house has provided a warming space and toilets for sledders on the steep hill behind it and ice skaters to the north. During Wirth's administration the house included office space for park engineers. It survived the tornado of 1981, but not without superintendent Fisher's wife being thrown down the stairs and his tax return sucked out the window. In the 1990s, the house was leased to the Minnesota Recreation and Parks Association. Now the Minneapolis Parks Foundation uses the house for office space.

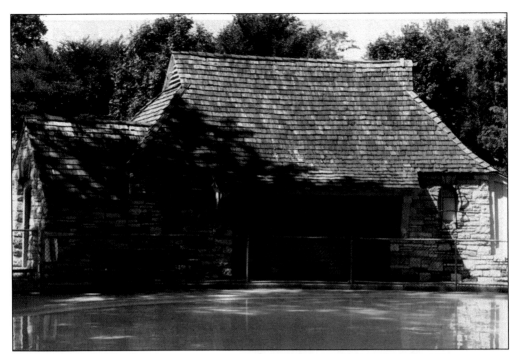

RIVERSIDE PARK. This handsome structure provides toilets for park users and a place for pool equipment. It can also serve as a base for playground activities. Built in 1928 with a wood shake roof, one might envision this to be Beatrix Potter's country home.

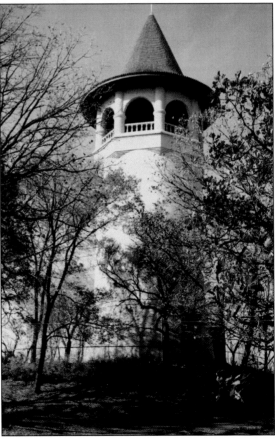

TOWER HILL PARK. Built prior to World War I, this tower was designed to be distinctive by city engineer Frederick Cappelen, who also designed the Franklin Avenue Bridge that carries his name. Described by architectural writer Larry Millet as "perhaps the most romantic structure in Minneapolis," the tower was saved from being torn down after its function as a water tower ceased. This poured concrete structure with a witch's hat sits on a high steep hill at 55 Malcolm Avenue SE. The late Ralph Rapson, once head of the university's architecture department, lived across the street.

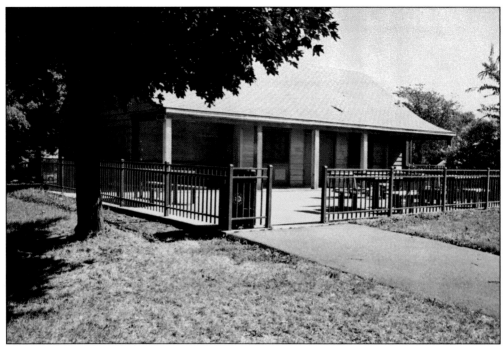

NICOLLET TENNIS CENTER. Constructed in 1937, this building was originally located at The Parade and used by The Twin City Tennis Club. When the Ice Center was constructed at The Parade in 1973, the clay courts used by the tennis club were relocated northward and the clubhouse moved to King Park. A smaller clubhouse was built for clay courts. This clubhouse is used as field office for Youthline park staff. A tennis club uses the "air-supported bubble."

PEAVEY FOUNTAIN. Located at Kenwood and Lake of the Isles Parkways, this fountain was donated by Frank Peavey so horses could have a drink. After World War I, this fountain was rededicated to the horses from the 151st Field Artillery that were killed in action. Horses are no longer allowed in the city, except for police use, but the fountain remains as a decorative memorial.

PHELPS FOUNTAIN. Fifty years ago, one would have seen this fountain downtown at the Gateway Park. When that park was reconfigured in the late 1950s and the pavilion torn down, the Park Board decided to relocate this fountain, donated in 1915 by park commissioner Edmund Phelps, to the Lake Harriet Rose Garden area (Lyndale Park). The fountain was created by sculptor Charles Wells.

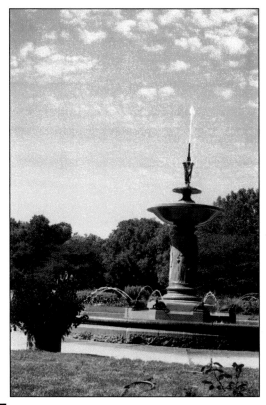

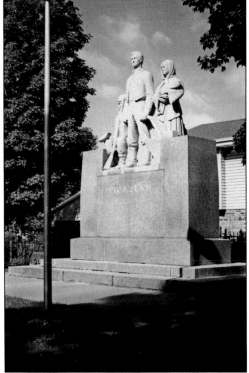

PIONEER SQUARE AND STATUE. Pioneer Square was acquired by the Park Board in the 1930s as an open frontispiece for the new main post office about to be constructed. The *Pioneer Statue* was designed and constructed by Minneapolis sculptor John K. Daniels. When Pioneer Square was sold to the Minneapolis Housing and Redevelopment Authority as part of the Gateway renewal plan, the statue was moved to a small triangle of parkland on Marshall Street NE at Main Street NE. The pioneers can be found there watching traffic.

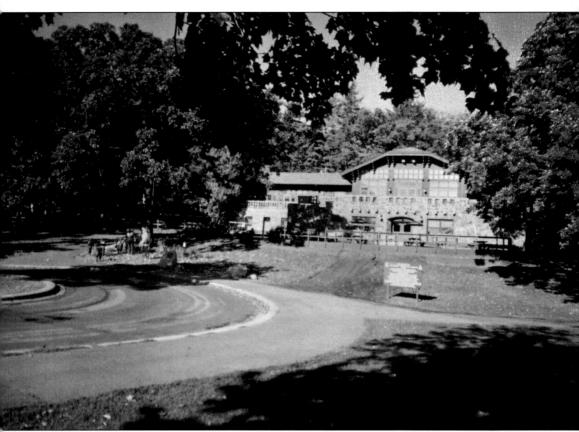

WIRTH CHALET. When Theodore Wirth and his bride returned from their honeymoon in his native Switzerland, they brought back a model of a Swiss chalet. In 1922, it served as a reference for the clubhouse at Wirth Golf Course. Wirth felt the architects Magney and Tusler had done a good job converting the model into a functional and useful clubhouse. It serves more than just golfers. In the winter, the fairways are etched by cross-country ski tracks. Snow tubers and sledders enjoy the steep hills of the course, which are strenuous to golfers who don't benefit from towlines. People can warm up with a hot chocolate in the club room and with a bit of imagination feel as if they are in the Swiss Alps. In the early days, a ski jump provided training for would-be Olympians. It was removed in the 1980s because of the costly repairs and the existence of other jumps in Hennepin County.

WIRTH AQUA FOLLIES STAGE. Adults over the age of 50 are probably the only people who would remember this scene. Built in 1941, this stage was the setting for the Aqua Follies. Those were the days when Buster Crabbe or Esther Williams made water shows popular in the movies or with outdoor settings like this. The Minneapolis Aqua Follies, a part of the Aquatennial, was possibly the granddaddy of them all. By the way, there still is a good swimming beach and a remodeled beach house at Wirth Lake. (Courtesy Park Board.)

WIRTH PICNIC PAVILION. Sitting high on a hill that overlooks Glenwood Avenue and Wirth Lake, this 1930 vintage structure is as attractive as the day it was built. It is difficult to access, but once there it does its job well for gatherings that want to enjoy a close association with the hilly woods of Wirth Park. Magney and Tussler are believed to be the architects of this light yellow, stucco building.

Two

NEW TREASURES

THE WAY THEY ARE VERSUS THE WAY THEY WERE. Many new structures in Minneapolis parks are replacements of earlier pieces. A great number of the recreation buildings are newer structures that replaced smaller buildings. Here is an opportunity to see both the present and the buildings they replaced. Only a few new structures in Minneapolis parks are the first of their kind. Don't miss the descriptions and photographs, as some of these have become icons.

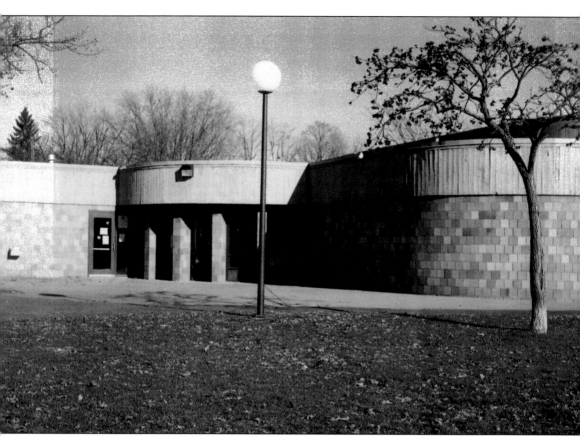

AUDUBON PARK. The first building at Audubon Park was a small shelter constructed in 1959. It was intended to provide space for park staff to conduct summer playground programs. In 1978, the shelter building was enveloped by a new structure of about 6,000 square feet and was intended to provide for year-round recreation programs. The space includes a multipurpose room, an arts and crafts room, and meeting rooms. There is a lobby reception area and administrative space for full-time staff.

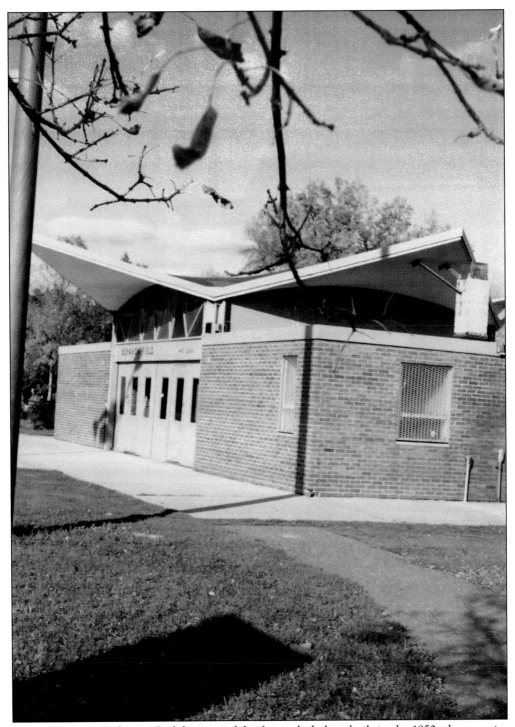

BOHANON PARK. Bohanon Park has one of the few park shelters built in the 1950s that remain. This one with its hyperbolic shell roof is unique in the park system. Although additional indoor recreation space was added to the Lind School adjoining Bohanon Park, this shelter still serves as a warming room in the winter and a base for summer playground activities.

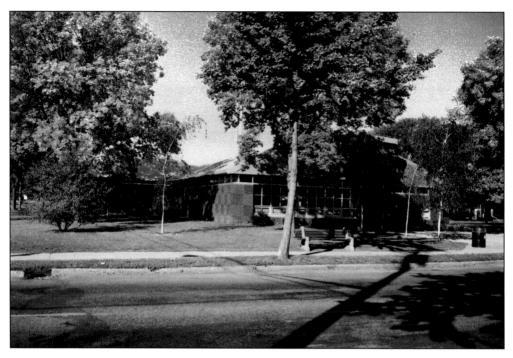

BOTTINEAU PARK. This recreation building is the third structure at Bottineau Park. The first was a small shelter built in 1956 that was replaced by a full-size recreation center in 1977. Shortly before the turn of the 20th century, it was destroyed by fire. The building pictured here was constructed in 2002. It is the largest of the three Bottineau buildings at 13,000 square feet. With a field house containing a basketball court and a running track, plus 3,000 square feet of multipurpose program space, it is a one-of-a-kind building within the park system. (Below, courtesy Park Board.)

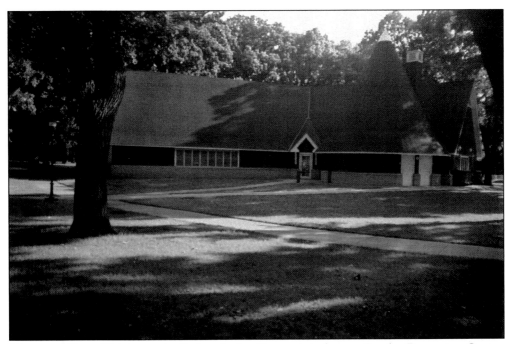

BRACKETT PARK. This is not the little red schoolhouse; it is the new Bracket Recreation Center, built just in time for the new millennium. Architect Milo Thompson's structure replaced Harry Jones's building that was constructed in 1924. Early sketches show it was designed to give a feel of the original while not being a copy—it stands very much as an original. It is the only red building in the park system and gives an uplifting feel in this very traditional Minneapolis neighborhood. (Below, courtesy Park Board.)

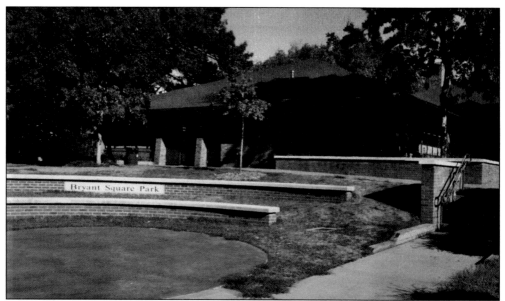

BRYANT SQUARE PARK. The Bryant Square Recreation Center replaced the original structure built in 1911. Prior to construction, the park site was filled to raise the grade to street level. In the late 1960s, the Park Board began a substantial increase in indoor recreation facilities. Neighborhood recreation centers would be 5,000 to 6,000 square feet in lieu of the 1,000- to 1,500-square-foot buildings constructed in the early part of the century. Designed by architect Jack Barclay of Chicago, Bryant Square was one of the first new neighborhood centers. This building, like many others to follow, contains a multipurpose room, an arts and crafts room, a kitchen, meeting rooms, and administrative space. One of its rooms opens directly to the park's skating rink, thereby making a warming room for skaters in the winter and space for playground programs in the summer. In this book, the reader will see many of the park system's neighborhood recreation centers built in the 1970s and early 1980s. All are intended to provide for a diversified range of indoor recreational pursuits. (Below, courtesy Park Board.)

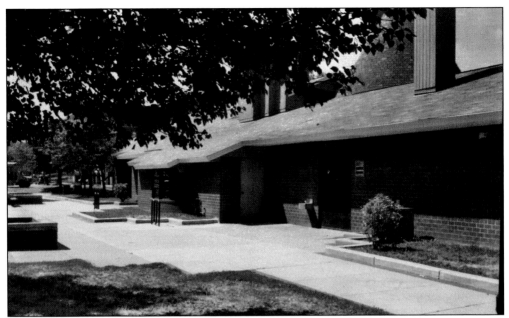

ELLIOT PARK. This is not a railroad station in a park, but rather a reflection of architect Milo Thompson's inspiration received from some of the houses in the nearby neighborhood. This very handsome structure literally encompassed the small building, constructed in 1950. Built in 1980 prior to the Americans with Disabilities Act (ADA), this structure incorporated into its design all the features that could be thought of to accommodate persons with disabilities, including tactile signs and a unisex toilet room. There are many institutions in the Elliot Park area that provide services for people with disabilities. These services have attracted a large percentage of people with disabilities to move into the neighborhood. At the time Elliot Center was built, it was envisioned as a forerunner for possibly three other centers of its type to be built throughout the city. However, the ADA legislation mandated that all public buildings have provisions for use by the disabled and the Park Board began a new program to revamp all its facilities. (Below, courtesy Park Board.)

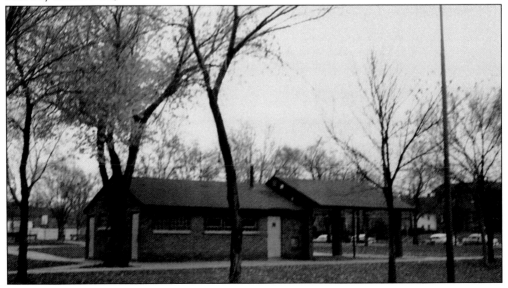

FARVIEW PARK. Nearly as old as the Park Board itself, Farview Park, with a name expressing its vantage overlooking the city, has served the near north side for well over 100 years. The park is noticeably teeming with young people. In the 1960s, the Park Board removed a lookout tower built in 1889 to make more space in the park. In 1976, a new recreation center was built, and in 1992 a full-size gym was added to the center. Both the 1976 building and the 1992 addition are a contemporary design with burnished block exterior. (Below, courtesy Park Board.)

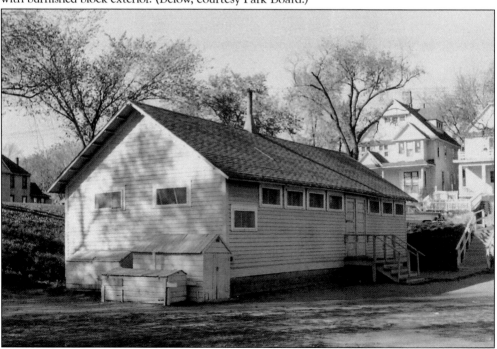

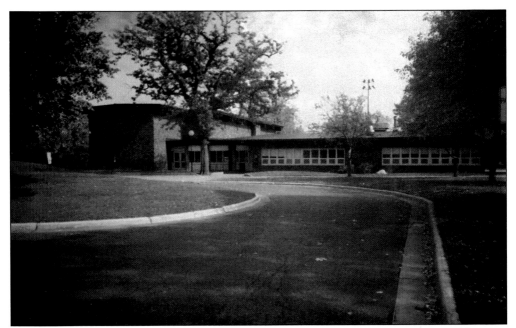

FOLWELL PARK. William Watts Folwell, a New Englander who came to Minnesota via Ohio, was president of the University of Minnesota and the Park Board commissioners, respectively. Both institutions have buildings named after him, albeit the university's is much larger. As the college's first president, Folwell set the tone for a major public university that carries through today. As a Minnesota historian, Folwell identified 12 great apostles of Minnesota. Among them was Charles M. Loring, whom he dubbed the "Apostle of Parks and Playgrounds." The Folwell Community Center, shown here, was built in 1970. It is a contemporary structure designed by Patch and Erickson. It has a gym auditorium, multipurpose room, space for arts and crafts, meeting rooms, a lounge, and administrative and support space. It replaced a smaller, earlier structure that was built in 1923 and tucked in the hillside with a rooftop bandstand. (Below, courtesy Park Board.)

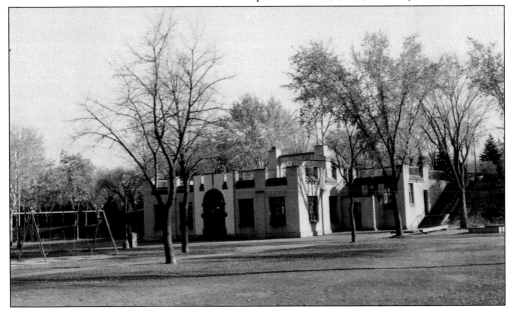

GROSS GOLF COURSE. In 1985, this contemporary brick building replaced the old wood frame clubhouse, constructed in 1925, and the refectory and toilet building constructed in 1958. Gross Golf Course was originally built on land leased from the Armor Meat Packing Company. When the land was purchased in 1947, it was renamed in honor of Frances Gross, one of the Park Board's longest-serving members. (Below, courtesy Park Board.)

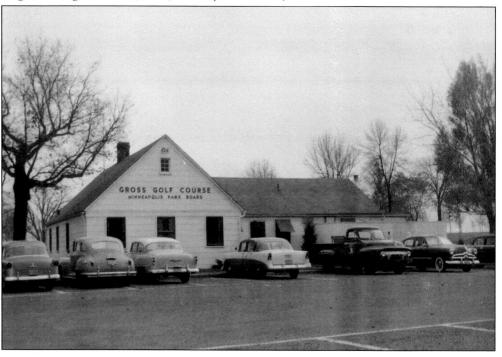

THE GATEWAY. In the city's early days, the Gateway was the arrival locale for early settlers coming by train. It was also the landing location for those crossing westward on the Hennepin Avenue Bridge. In 1915, Gateway Park was graced by a beautiful pavilion designed by Hewitt and Brown. Architectural writer Larry Millet described it as possibly the best Beaux Arts example in the Twin Cities. Its last use was by the Minneapolis Tourism Bureau. When that group left in the 1950s, the building was left alone except for vagrants. It was demolished in the 1960s as part of the Washington Avenue/Gateway urban renewal area and replaced by a fountain designed by Park Board staff. The original fountain, designed to be in consonance with the pavilion, was donated by park commissioner Edward Phelps in 1915. When the pavilion was demolished, the Phelps Fountain was relocated to the Lyndale Garden area. The flagpole, which was placed at the Gateway on the Fourth of July in 1917 by the Daughters of the American Revolution, remains there with the new fountain and surrounding new buildings. (Below, courtesy Park Board.)

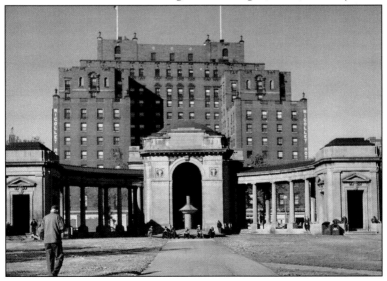

LINDEN HILLS PARK. Built in 1972, the Linden Hills Recreation Center may have been one of architect Ron Pontinen's most trying commissions. He lived nearby, along with many residents. Several people could not see why the park should be changed. They loved the old bank of four concrete tennis courts and felt the Park Board's recently adopted objectives for park buildings and sites were being pushed on them. In the midst of Pontinen's quiet patience and the neighborhood's noisy persistence, a building plan evolved fairly closely following the Park Board's new objectives. This structure's multipurpose room is slightly larger than usual with more of an athletic twist. The old building, constructed in 1921,was torn down and the old bank of four tennis courts was replaced with two new blacktop courts. The new play lot became exceptionally popular with adults and children from well beyond Linden Hills. (Below, courtesy Park Board.)

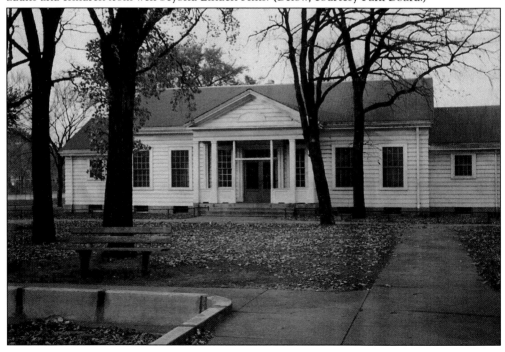

KING PARK. As one of the older and larger parks in the city, Martin Luther King Park was originally called Nicollet Field. The original building, constructed in 1939, was ornate with a very large wading pool. It was one of the first to have a full-time professional recreation staff. This new building, constructed in 1970 when the park was renamed in honor of Dr. Martin Luther King, followed—with some exceptions—the Park Board's new concepts for recreation centers. (Below, courtesy Park Board.)

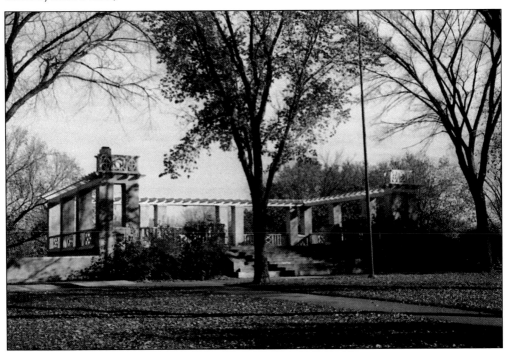

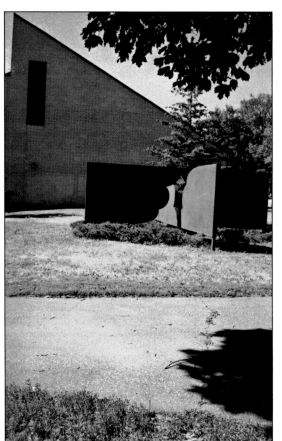

King Park Freedom Form No. 2.
This large abstract sculpture, placed in the park in 1970, generated its own controversy—not the design or symbolism, but its location. The sculptor and landscape architect could not agree. Park superintendent Robert Ruhe was tempted to ask Dr. Ralph Bunch, then U.S. ambassador to the U.N. who was scheduled to speak at the dedication, to negotiate an agreement. Cooler heads prevailed, and the issue was overcome.

Keewaydin Park. The recreation center at Keewaydin Park has no predecessor except for a couple of rooms leased from nearby Keewaydin School. These rooms provided warming space for skaters and some program space year-round. Built in 1972, the Keewaydin Recreation Center, designed by Miller Dunwiddie, is an example of an early full-size recreation center in the park system that provides multipurpose space, arts and crafts meeting rooms, a lobby lounge, and staff administrative space. This contemporary brick structure fits comfortably within its neighborhood.

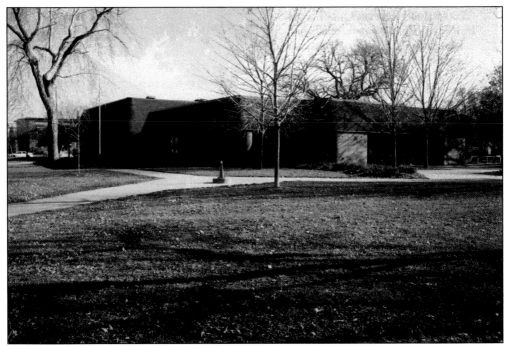

LOGAN PARK. The Logan Community Center was a very difficult project for northeast Minneapolis residents. Their old building was large and had served since 1913, and they were very attached to it. Its large shower rooms had served early immigrants whose houses often had no indoor bathrooms. An architectural study showed it was more costly to renovate than to build a new structure. Built in 1971, this contemporary brick structure by architect Ron Pontinen has served the northeast community well. It followed the Park Board's concepts for community centers and includes a full-size gym to double as an auditorium as well as a multipurpose room, kitchen, arts and crafts room, lobby lounge, meeting rooms, and staff administrative space. (Below, courtesy Park Board.)

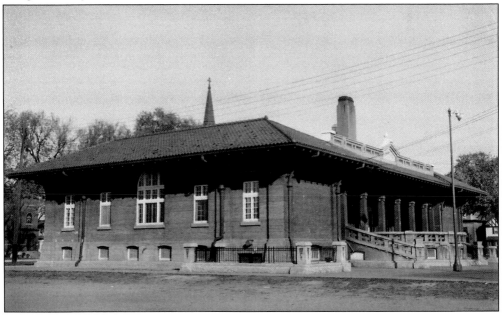

LONGFELLOW PARK. Longfellow was the first year-round recreation building to be constructed after World War II. Built in 1961, it was a part of the Park Board's postwar, strategic response to meet current and future needs. The plan, prepared by L. H. Weir, field secretary of the National Park Association, urged the Park Board to construct year-round buildings suitable for multiple recreation programs. In 1975, the Longfellow building was renovated and expanded to include a full-size gym. It then met the Park Board's recently adopted concepts for community centers. (Below, courtesy Park Board.)

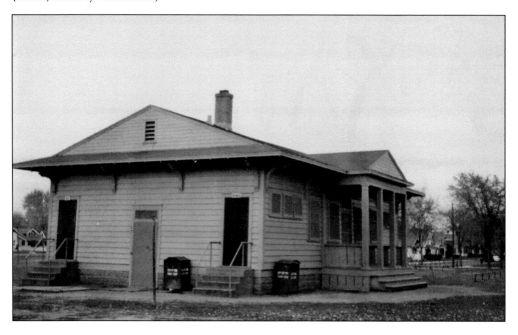

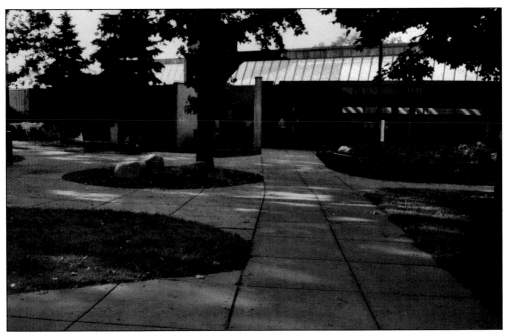

LUXTON PARK. The Luxton Recreation Center, built in 1969, replaced the small shelter constructed in 1921. The 1969 structure, designed by Hodne and Associates, received an award from the American Institute of Architects. It is a handsome two-story contemporary building of wood and concrete. With its integrated outdoor wading pool, its design is very urbane; it could have stepped out of the pages of any architectural magazine. However, with functional space on two levels, programming was difficult. When the full-size gym was added in 1992, architectural firm Bentz, Thompson and Rietow worked with staff to minimize programming difficulties. (Below, courtesy Park Board.)

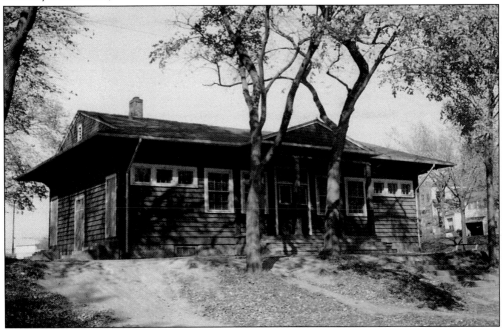

LYNNHURST PARK. The handsome, small shelter building at Lynnhurst stood for 43 years in the center of the park. In 1971, it was replaced by a new facility added to Burroughs Elementary School on the south side of Fiftieth Street. It left the park site clear for expanded athletic fields, but it was without an identifiable building except for a new shelter to warm skaters and provide a base for summer play activities. The 1971 building, attached to the school gym, was the equivalent of other new park community centers being planned throughout the city. (Below, courtesy Park Board.)

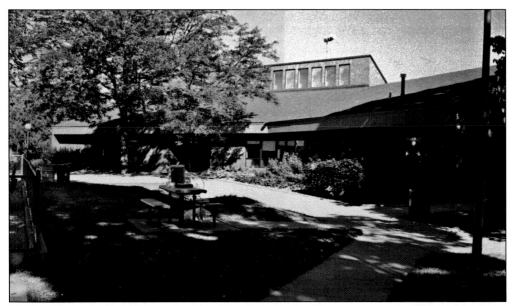

MCRAE PARK. McRae Park, with its small brick shelter building, was typical of the neighborhood parks of the 1950s and 1960s. But when older neighborhood parks were being upgraded with new year-round centers, whose 5,000 to 6,000 square feet offered space for indoor activities, neighborhoods like McRae also wanted new facilities. In 1976, architect Dwight Churchill planned a new structure to be built around the existing shelter. This handsome brick building, with modifications for accessibility and energy efficiency, has served for the past 33 years.

POWDERHORN PARK. This legendary park in the middle of south Minneapolis has many claims to fame, including its speed-skating track, sing-along concerts, pageants, and Fourth of July fireworks. The gym/auditorium added to the original building in 1972 gives the composition of what stands today. The 1999 renovation gives the final look of the photograph. The style of the original building, with its broad overhanging soffit, hip roof, and lakefront setting, defines its architectural character.

MINNEAPOLIS-SAINT PAUL INTERNATIONAL AIRPORT. This structure also pertains to park architecture. In the 1920s, the Park Board commissioners purchased an old automobile raceway to convert it into a flying field (the Minneapolis City Council had no authority to purchase land outside the city's corporate limits). Concrete runways were constructed as well as a terminal building and hangers. The Park Board owned and ran this municipal airport until 1943, when the Metropolitan Airports Commission was created. The Park Board is still the underlying fee owner of the original land, which is approximately one third of the current airport. Pres. George H. W. Bush earned his navy wings here, and two Russian jetliners carrying soviet premier Mikhail Gorbachev sat on the Park Board's original holdings. The new terminal was constructed in 1961. Thorshov and Cerny were the architects for this handsome folded plate structure. (Below, courtesy Park Board.)

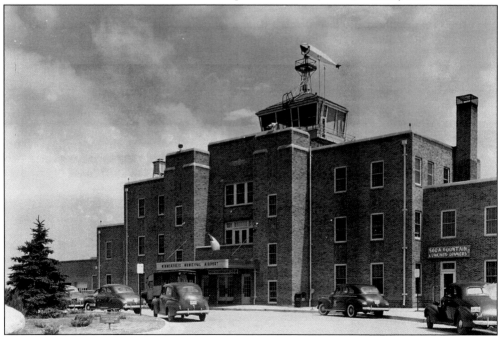

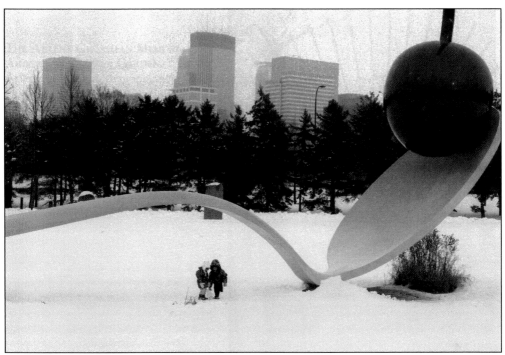

MINNEAPOLIS SCULPTURE GARDEN. The *Spoonbridge and Cherry* centerpiece of the Minneapolis Sculpture Garden started as a sketch drawn by Claes Oldenburg on a piece of scrap paper. That sketch stuck in the back of Walker Art Center director Martin Friedman's mind until the sculpture garden could become a reality. This large sculpture, designed by Oldenburg and his wife, Coosje van Bruggen, was built by a boat factory in Maine and shipped and placed in the central court. The sculpture garden had its precedence as far back as 1915 with the Kenwood demonstration gardens, which sat there until the construction of the I-94 tunnel in the 1960s. The area then became an open green area until the Minneapolis Sculpture Garden, a joint project between the Walker Art Center and the Park Board, was completed in 1988. (Above, photograph by Tom Dombrock.)

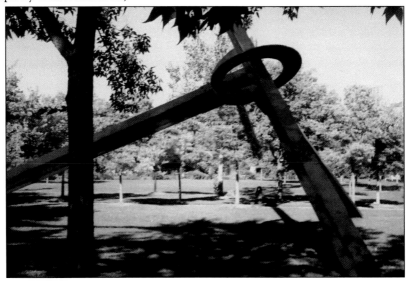

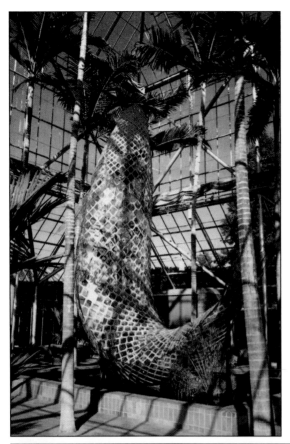

MINNEAPOLIS SCULPTURE GARDEN, COWLES CONSERVATORY. The Cowles Conservatory is another major piece of the sculpture garden. Before architect Edward Barnes's plan for the garden was presented, the Park Board had twice prepared similar plans for the area. Each had a covered walkway from the parking area to the Walker Art Center. Barnes's plan grew to a full-fledged glass conservatory, complete with a nearly two-story-high Frank Gehry fish made of glass. When the sculpture garden and conservatory opened in 1988, the news went nationwide. The *New York Times* called it "the finest new outdoor space in the country for displaying art." A supermarket tabloid described it as "wacky art."

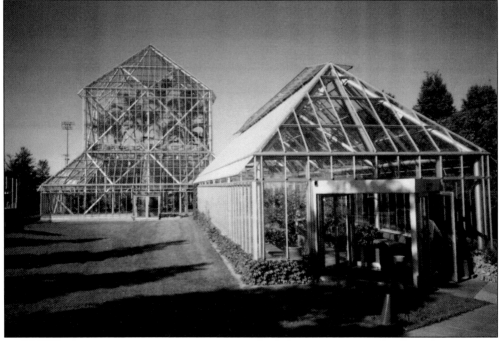

THE ARLENE GROSSMAN MEMORIAL
ARBOR AND FLOWER GARDEN. The
Arlene Grossman Memorial Arbor and
Flower Garden, designed by landscape
architect Michael Van Valkenburgh,
capped off the second phase of the
sculpture garden completed in 1992.
The Irene Hixon Whitney Bridge
(below) was constructed as part of
the Minneapolis Sculpture Garden
project. Previously the Minneapolis
city engineer and the Minnesota
Department of Transportation tried
to create a pedestrian bridge over the
Hennepin/Lyndale bottleneck but
faced opposition from the Walker Art
Center. Lacking funds, the bridge did
not materialize. With inspiration from
arches of the 100-year-old Hennepin
Avenue Bridge, Minneapolis-based
sculptor Siah Armajani developed
his inverted-arch design, which
was funded in part by Irene Hixon
Whitney. This outdoor artwork,
the largest in the state, is owned
and maintained by the Minnesota
Department of Transportation.

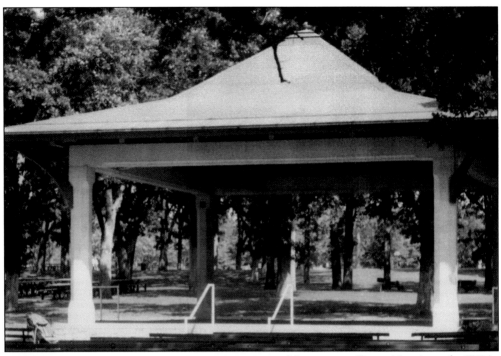

MINNEHAHA PARK. Not since the WPA days had many improvements been made to Minnehaha Park, except for the Wabun picnic area in the 1950s and the trail in the lower glen in the late 1960s. By the early 1990s, the time for improvements had come. With the help of a citizen advisory committee and a team led by landscape architects Sanders Wacker Bergly, the Park Board had a master plan for improvements. Some of the new structures in the park are shown here, including furnishings, arbors, shelters, and a new bandstand.

MINNEHAHA PARK, WABUN PICNIC AREA. The area has long been a desirable gathering place for large group picnics. Just completed, the new shelters—two large eight-sided structures and two slightly smaller hexagonal buildings—replaced the single shelter constructed in 1959. They make a lively appearance in keeping with the classic traditions of Minnehaha Park. A totally new facility to this picnic area is a wading pool with a fountain. It is just as popular with adults as to children.

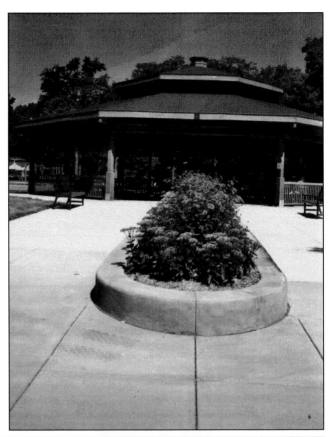

NOKOMIS BATHHOUSE. The comparison between the original bathhouse, built in 1919, and the current one, constructed in 1967, is striking—both architecturally and socially. When the first was built, people wore dress-up clothes to go to the beach; it may well have been a ride on the trolley to get there and the better part of a leisurely day spent on a much more crowded beach. Now people drive, walk, or bicycle in jeans or shorts and spend little, if any, time on the beach; they prefer bicycling or walking around the lake. The current brick bathhouse has no-nonsense, clean, straight lines typical of the era in which it was built. It is doubtful that anyone actually changes clothes in it, but it serves as a toilet building and a base for lifeguards. (Both courtesy Park Board.)

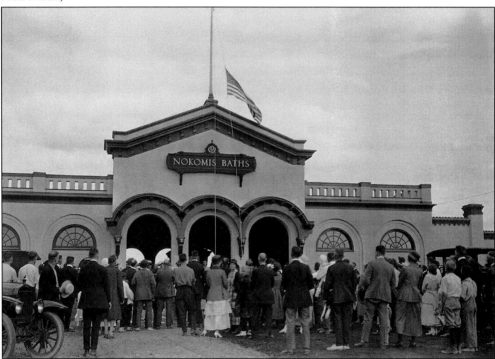

NOKOMIS COMMUNITY CENTER. Architect Ron Pontinen literally designed this building standing on his feet before an apprehensive crowd on a hot summer eve. Many did not think it was needed. There had been no precedent for a community center in the Nokomis community. This brick contemporary building with a 1950s flair has a full-size gym that doubles as an auditorium and a multipurpose room with a kitchen, an arts and crafts room, and meeting rooms. The old Nokomis Picnic Pavilion, its only possible predecessor, was removed to make way for it. The multipurpose room in the new building was designed to include direct outside access to a patio as a substitute for the picnic pavilion. Sitting on a hill on the north side of Lake Nokomis, the building has excellent rapport with its site. The lobby lounge provides an expansive view overlooking the water. (Below, courtesy Park Board.)

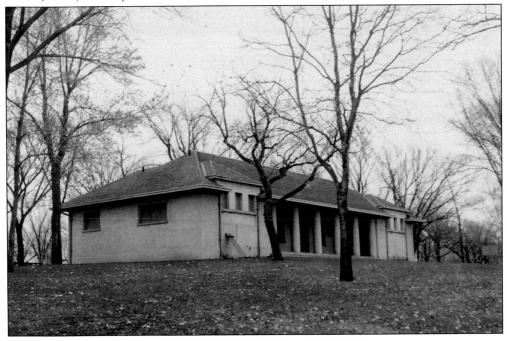

NORTH COMMONS PARK. This park has been a mainstay for the near north community in Minneapolis since it was acquired in 1907. Its first recreation building was burned in 1975 just before it was replaced by the current one. This current building, a contemporary brick structure, was designed by architect Roger Johnson, a former associate of Eero Saarinen, the designer of the Gateway Arch in St. Louis. The building includes a full range of community center spaces, including a gym and space for social service groups. Its slightly curved corners and other refinements reflect a Saarinen influence. (Below, courtesy Park Board.)

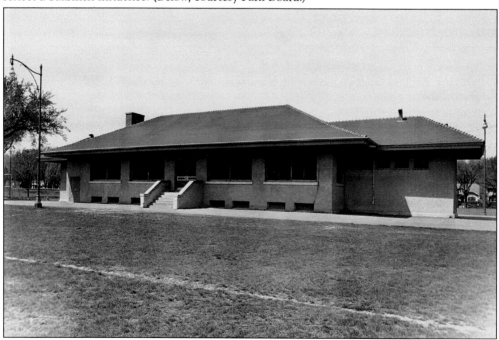

PARADE ICE CENTER. When the ice center was completed in 1974, it was a major new addition to the park system. This contemporary brick structure by Adkins Jackels Architects has both a hockey rink and a studio rink. In 1987, an additional hockey rink was added to replace the one lost when the old civic auditorium was torn down. The ice center starred in two *The Mighty Ducks* movies made by Disney Studios in the 1990s.

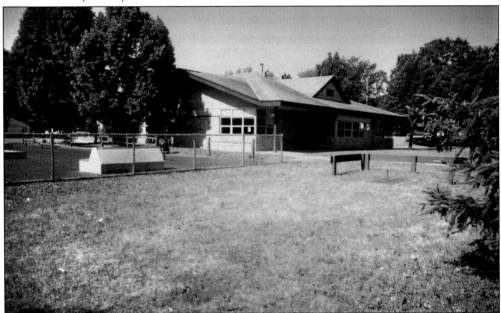

MORRIS PARK. If ever a park is named after commissioner Dale 'Skip" Gilbert, this should be it. No one waited longer or sought as much to have Morris Park's little shelter expanded. This building, carrying the same name as the adjoining Morris School, was constructed in 1993. It serves a relatively small neighborhood and, at 4,600 square feet, is not as large as most recreation buildings, but it was a joy to commissioner Gilbert before he died.

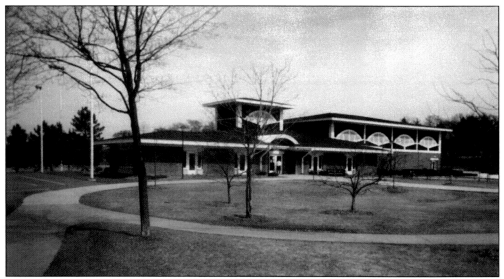

PEARL PARK. Pearl Park serves a substantial portion of south Minneapolis. So much so that the Hale-Page-Diamond Lake neighborhood used $1 million of its neighborhood revitalization money to add a gym to the existing recreation building. Architect Milo Thompson did not reveal his design inspiration for this building. When the gym was added to the existing building, the interior floor plan was revamped, and a new exterior was designed for the entire structure. Escaping a design label, this new composition is perhaps the most imaginative way of treating a building with a full-size gym on a site lacking any particular features such as a hill, gorge, valley, or overlook. (Below, courtesy Park Board.)

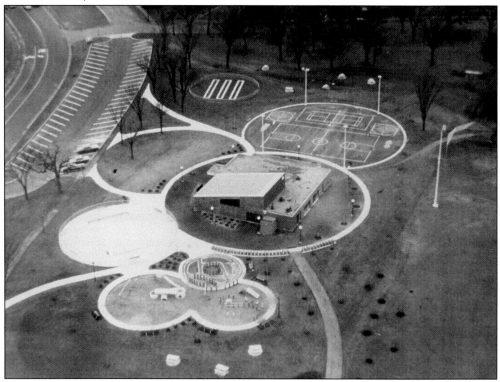

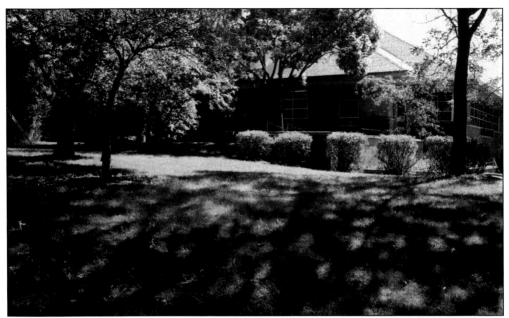

Operations Center. Col. W. S. King's old horse barns at Thirty-eighth Street and Bryant Avenue were the beginning of the main operations and maintenance facility of the park system. Major additions and changes occurred in 1912 and 1931; further changes came in the early 1980s. The architectural challenges were many. On the west was Lakewood Cemetery, whose occupants comprise a who's who list of prominent Minneapolitans, including H. W. S. Cleveland and Theodore Wirth. On the east is Lyndale Farmstead Park. The southwest area is home to the superintendent's house and one of the city's finest sledding hills. The remaining area surrounding the site is residential. Architects at Ellerbe Becket solved all concerns with the office area located nearest the residential area. The industrial portions are tucked into the natural slope of the site, and a storm-water holding area is placed on the far corner of the outside service area, which is surrounded by a masonry and stucco fence. (Below, courtesy Park Board.)

SIBLEY PARK. Word had it that young architect Ron Pontinen surprised park staff with the design for the Sibley Recreation Center. No one said what the staff had expected. This building, constructed in 1969, was one of the early centers following the Park Board's recently adopted concepts for the design of recreation buildings. It replaced an earlier building constructed in 1928. Its brick contemporary design fits softly in the neighborhood it serves and earned Pontinen several other commissions where expectations were varied and sometimes controversial. (Below, courtesy Park Board.)

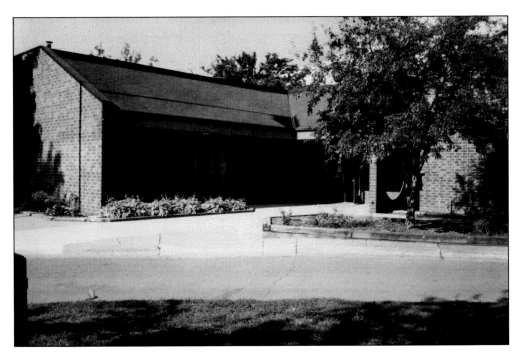

PERSHING PARK. Located in the southwest corner of Minneapolis, Pershing Perk has served its neighborhood well since it was acquired in 1922. A shelter (below) was built in 1924, and 50 years later it was replaced by a full-blown recreation center. This contemporary brick structure provides year-round service with rooms and facilities that are typical of a desirable neighborhood recreation center. (Below, courtesy Park Board.)

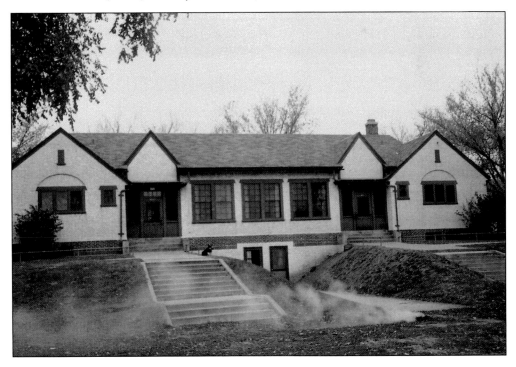

Van Cleve Park. The little Van Cleve shelter of a bygone era was replaced in 1970 by a building 10 times its size, which provided a full compliment of interior recreation space and a full-size gym. Renovated in 1999 for accessibility and other needed improvements, this brick contemporary structure represents one of the first community recreation centers in the park system and was designed to provide ample opportunities for recreational activities year-round. (Below, courtesy Park Board.)

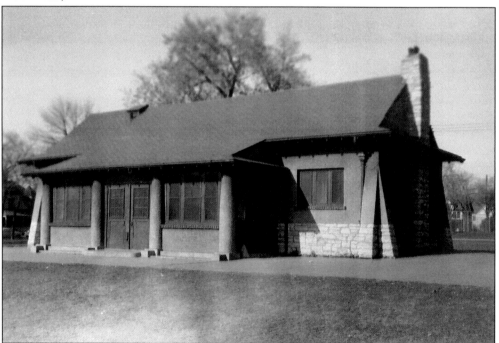

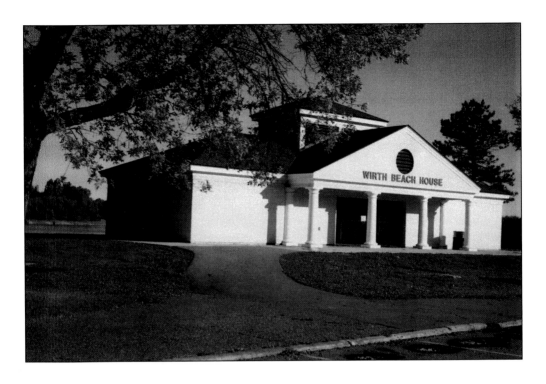

WIRTH BEACH HOUSE. The extreme makeover of the remains of the old bathhouse uplifted the whole appearance of Wirth Beach. It made a new statement reminiscent of the original bathhouse, which was "Wirth Lake is a great place to be." (Below, courtesy Park Board.)

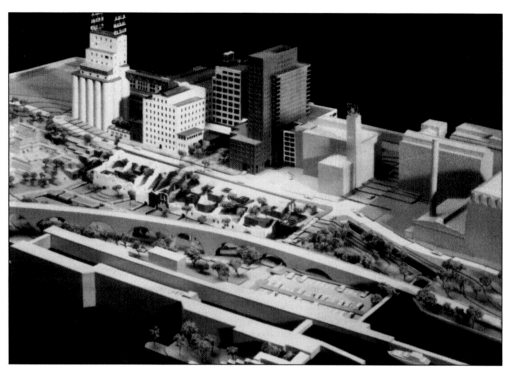

GREAT RIVER ROAD AND MILL RUINS PARK. In 1937, Secretary of the Interior Harold Ickes conceived the idea of a road that would run continuously along the Mississippi River. The idea lay dormant for nearly 40 years. When it was revived, every state and city adjoining the Mississippi picked an existing road near the river as its route. The exception was Minneapolis, which planned the only new section. This 3-mile piece would extend the existing West River Parkway to downtown and beyond to Plymouth Avenue. The route would go through the old west bank milling district. Russell Fridley, then director of the Minnesota Historical Society, thought the road should go around the milling district; others thought the road should be as near the river as possible. Fridley finally proposed a compromise that would allow the road to go through, provided that a ruins park be created where the buried footings and tailraces of the old mills would remain.

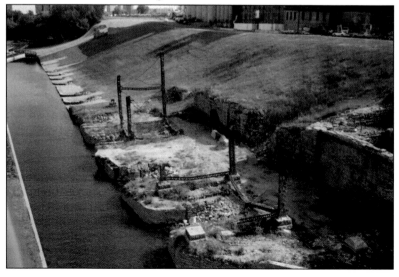

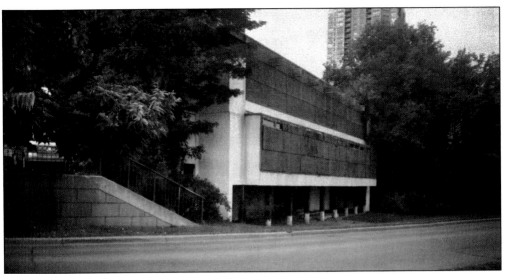

FUJI YA. This was built in the 1960s by Reiko Weston, a Japanese immigrant who, legend has it, was looking for a new job opportunity for her father, a Japanese admiral. Diners enjoying her fine Japanese cuisine had the advantage of an extraordinary view of the horseshoe-shaped portion of Saint Anthony Falls. The Park Board acquired the building in 1985 from Mrs. Weston's son and daughter. This first piece of riverfront development sits on the foundations of old mill buildings. It has the most interesting basement of any restaurant possibly anywhere.

HENNEPIN BLUFFS PARK. Hennepin Bluffs is part of the 150 acres of parkland that surround Saint Anthony Falls. The total park holdings are considered Minneapolis Central Riverfront Regional Park Area. This little shelter/performance structure marks the approximate location where Fr. Louis Hennepin was shown the waterfall by his Dakota captors in 1683. In less than 200 hundred years, he would have been looking at the milling capital of the world—all brought about by the power of the waterfall, which he named after his patron, Saint Anthony of Padua.

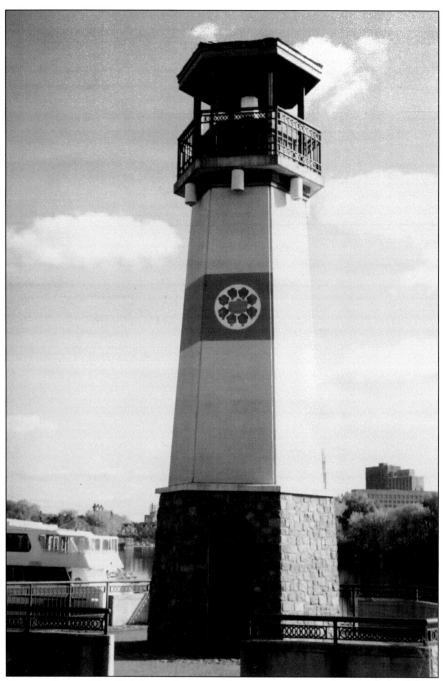

BOOM ISLAND LIGHT. This lighthouse has been featured on postcards and in travel magazines. It was most recently presented in a handsomely bound volume entitled *Lighthouses* by Michael Vogel. Built in 1987 as the centerpiece of Boom Island Park, it is the brainchild of Ted Wirth Associates in conjunction with landscape architects Tushie Montgomery. It marks the entry to a small boat basin built in the park. The lighthouse is believed to be the only one of its kind on the Mississippi River. It sits at the 45th parallel, where Plymouth Avenue crosses the river. It has no predecessor and has become an icon of the park system and the city.

BOOM ISLAND. This island derives its name from the early log-booming days, when the city was mostly forest and logs were floated down river. At one time, it really was an island. The back channel was filled at some unknown point, but the name remains. It later became a rail yard for the Wisconsin Central. The Park Board acquired it from the Bollander Company that used it as a recycling operation, crushing demolished building pieces and placing the material back on the building supply market. The acquisition fulfilled a promise by the city to nearby residents that the island would become a park.

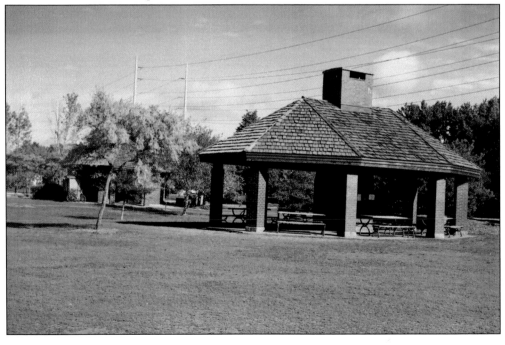

COLUMBIA LEARNING CENTER. The concept of a golf learning center emerged in the park system in the 1990s. Designed to provide a putting, chipping, and driving experience with a clubhouse facility, it is intended to foster interest in the game, especially for young would-be golfers. Built in 1995 and designed by Paul Maddsen, the Columbia Learning Center is the first in the park system. It sits along Saint Anthony Parkway at the south end of the golf course.

CORCORAN PARK. There is no predecessor for Corcoran, save for an old school building. The land for Corcoran Park was acquired from the Minneapolis School District in 1975. Corcoran Park was one of several that were acquired in the 1970s for neighborhoods that, for one reason or another, were passed by in earlier days of the city. Corcoran Recreation Center, with a multipurpose room, arts and crafts space, a warming room, meeting rooms, a lobby, and staff administrative space, provides a full range of indoor recreation opportunities appropriate for a residential neighborhood.

FULLER PARK. The opportunity for the Park Board to acquire the old Fuller School site arose so quickly that a committee, formed by nearby residents to encourage the acquisition, became alarmed. The Fuller Recreation Center, built in 1975, is one of the few two-story structures in the park system. Site constraints forced the design, which seems to work fairly well in spite of two levels.

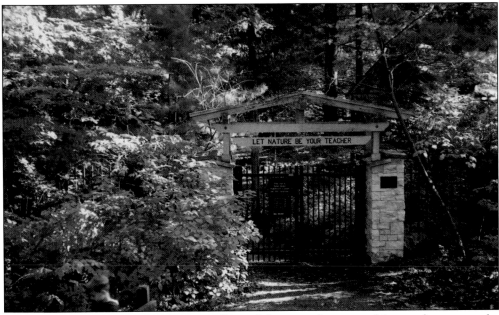

ELOISE BUTLER WILDFLOWER GARDEN. One of the more fortunate things to happen to the Minneapolis park system was the development of the Eloise Butler Wildflower Garden in 1907. Situated in a rolling area on the eastern side of Wirth Park, it offers a rare opportunity to experience the abundant natural species of the area. The entry area was enhanced from a simple gate to a feature that architecturally stood on its own and befitted a garden of Eloise Butler's stature.

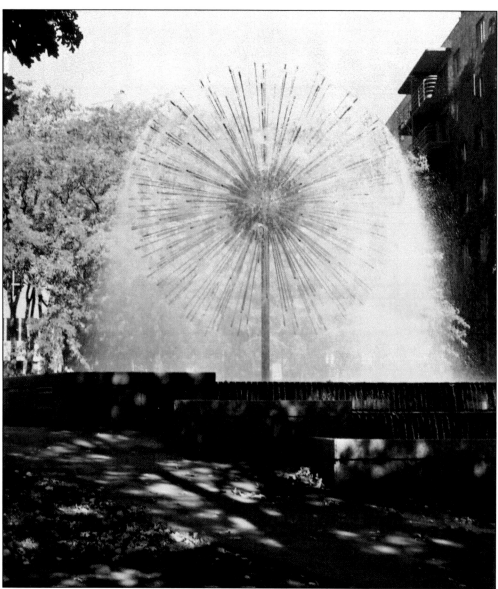

THE BERGER FOUNTAIN. This fountain arrived, dismantled, from Australia looking like the world's largest Tinker Toy set. It was a gift from park commissioner Ben Berger, who became enamored with the fountain he saw in Sydney that was dedicated to the soldiers who died in the World War II battles at El Alamein. The Park Board accepted it with Berger's proviso that no additional land be acquired for it. Its Australian architect, Thomas Woodward, recommended an entertainment district, but there were no public lands along Hennepin Avenue, the city's primary entertainment locale. This left the Park Board in a quandary until city coordinator Tommy Thompson asked that it be placed in Loring Park as a visual terminus to the Loring Greenway. Berger's predicament came when bids for the base and equipment were considerably higher than an estimate previously given to Berger. Later Berger admitted privately that he made enough from popcorn sales when his theater showed the long-running, spine-chilling thriller *The Exorcist* to cover the costs. Now some local park users take the thrill of cooling off on hot summer days in the fountain's spray and pools.

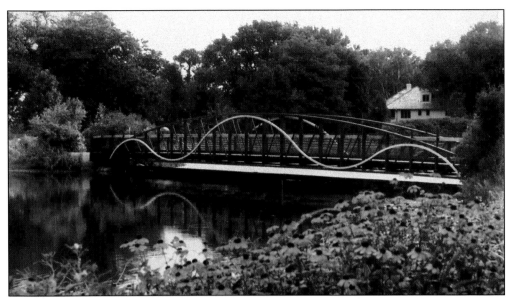

LAKE CALHOUN WETLAND BRIDGE. In the mid-1990s, the Park Board embarked on a goal of establishing wetlands as part of improving water quality in the city's lakes; wetlands act as natural filtering beds before storm water enters the lakes. In October 1995, the wetland at Lake Calhoun was dedicated. This interesting bridge, placed in the southwest area of Lake Calhoun, is designed to enable people to experience the wetland as a feature in itself. It is a new experience and quite a contrast from the usual almost-hectic activities at the lake.

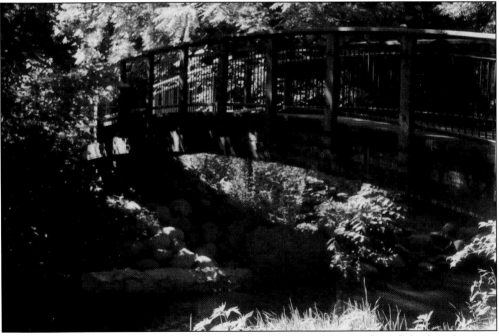

MINNEHAHA CREEK BRIDGE. This is only one of many small pedestrian/bicycle bridges that cross the city's creeks. Some were designed specifically; many were premanufactured or adapted from manufactured bridges. They provide pleasant opportunities to walk over or paddle under structures, or they can be simply appreciated as added attractions to the park scene.

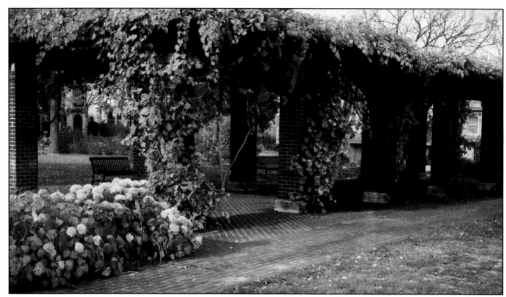

THOMAS LOWRY PARK. This neat little spot of parkland in the Lowry Hill neighborhood, sometimes called "Seven Pools," has been around since about 1919. It was refurbished in 1995 using the design of landscape architect Damon Farber. Architectural writer Larry Millet described it as an "urbane little park with brick paths, a grape arbor, a rambling watercourse and a bench ideal for whiling away time in unproductive fashion."

MUELLER PARK. The shelter building at Mueller Park has no predecessors except possibly the half block of houses acquired to provide the park site in 1973. The size of the building was proportioned to reflect the number of people in the small East Lowry Hill neighborhood, which like nearly a dozen other neighborhoods, had been passed over during the city's early days. This brick building provides warming space for skaters and a small multipurpose meeting room for year-round use.

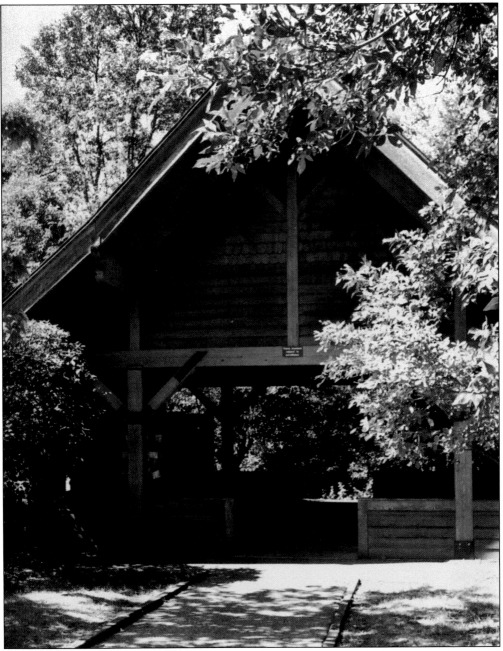

ROBERTS BIRD SANCTUARY. After the tornado and winds of 1981 nearly devastated Roberts Bird Sanctuary, careful restoration was needed. Part of the restoration work was the provision of a new entry area. It was a way of saying, "We nearly lost this quiet piece of refuge right in the heart of the city. Lets not ever take it for granted."

NORTH MISSISSIPPI PARK, NATURE CENTER AND PICNIC PAVILION. The efforts to provide parkland on the Mississippi River had been long thought about, arduous, and tricky to accomplish. However, by the early 1950s the Park Board had acquired a strong foothold in the vicinity of Shingle Creek and upstream. Then came I-94, and the entire site was threatened. In a settlement that culminated in a meeting in Mayor Al Hofstede's office in 1974, the park was made longer and narrower to accommodate the freeway. The Metropolitan Council later accepted it into the regional park and open-space system and funded the initial park development. The nature center, owned by the Park Board and operated by the Three Rivers Park District, bears the name of Carl Kroening. Kroening is the Minneapolis state senator whose political savvy, along with that of Sen. Bill Luther, representing Brooklyn Center, helped make the development of this park possible.

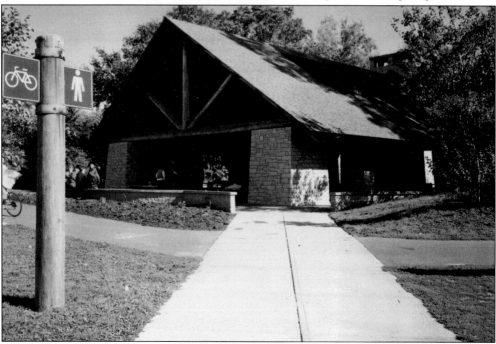

Three

BORROWED TREASURES

SOMETHING BORROWED. Minneapolis parks and parkways practically own the downtown area. From a distant view on Wirth Parkway to a close-up from Boom Island, downtown is almost always visible to anyone on a Minneapolis parkway or park. Also evident are many noteworthy structures, ranging from historic buildings to the ultra-modern. These are not found in parks but are easily seen and often accessed from them. West River Parkway ("the Great River Road") travels through the Saint Anthony Falls Historic District, providing views of the district that once made Minneapolis the milling capital of the world. Most of the standing mill buildings have been rehabilitated as condominiums or offices. The WCCO (Washburn Crosby Company) mill is now the Mill City Museum. Where some of the mill buildings no longer stand, their remains are preserved as a ruins park. The mansions overlooking the city's lakes provide a range of architectural experiences from Victorian to Frank Lloyd Wright–inspired contemporary. There is an exchange of sceneries between lake users viewing the mansions and mansion owners viewing the lake.

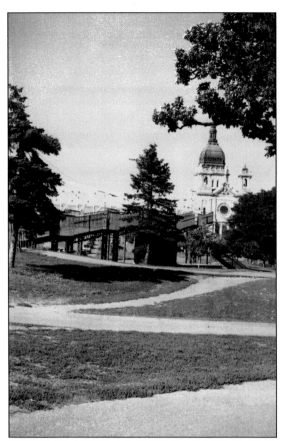

BASILICA OF SAINT MARY. Sitting behind the trees of Loring Park is the procathedral of the Archdiocese of Saint Paul and Minneapolis. Built in 1914 at the same time as the Saint Paul Cathedral, it is the product of the double vision of Archbishop John Ireland, who saw a need for two cathedrals at the same time he saw Minneapolis and Saint Paul being one major joined area. Designed by Emmanuel Masqueray of France, it is said to combine renaissance, baroque, and neoclassical styles. At 1000 Hennepin Avenue, it is a member of the cathedral club joining Saint Mark's Episcopal Cathedral and Hennepin Avenue United Methodist Church.

THE BAKKEN MUSEUM. A rainy Saturday afternoon, preferably in late fall, is the perfect time and weather to visit this stone mansion designed by architect Carl Cage and built in 1930. This Tudor Revival–style mansion was sold in 1976 to Earl Bakken, cofounder of Medtronic, the maker of cardiac pacemakers.

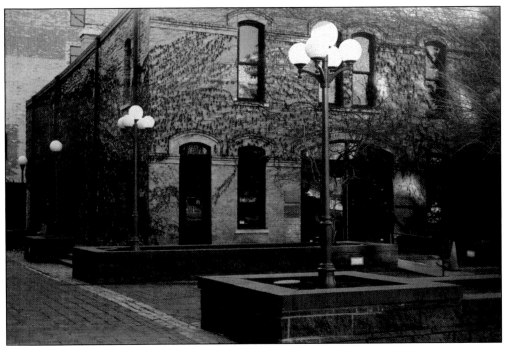

BROWN RYAN LIVERY STABLE. This limestone structure, built in 1880 at 20 NE Second Street, was moved about 100 years later by the Minneapolis Community Development Agency to the Saint Anthony Main area just off Main Street. It now serves as a commons area for Riverplace/ Saint Anthony Main.

BNSF BRIDGE. This stubby little steel truss bridge would not be suspected of carrying 100-plus car freight trains across the mighty Mississippi. It is on the Burlington Northern Santa Fe's main line from Chicago to Seattle. Twice a day it also carries Amtrak's "Empire Builder" (eastbound in the early morning and westbound in the late evening). It is the only passenger train between Chicago and the Pacific Northwest. One can almost touch it as it crosses Nicollet Island at the east end of the bridge.

CALHOUN BEACH CLUB. Designed by Charles W. Nicol of Chicago in 1928, the building in the center of the photograph didn't open until 1946 because of the Depression and war. This building and the one to the right were the focus of a major controversy when the building on the right was planned to be 25 stories and constructed on the beach club's parking lot. Under strong objections from many sources, a compromise was reached, limiting the new building to be no higher than the beach club. By 2002, the new building was completed and the Calhoun Beach Club was renovated.

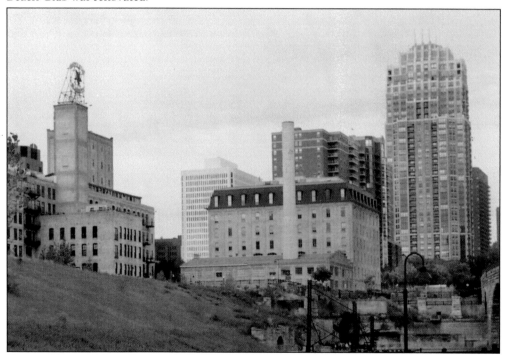

CROWN ROLLER MILL. Built in 1880 at 105 Fifth Avenue under the design of engineer W. F. Gunn, the mill remained in operation until the 1950s. It was renovated in 1985 and provides office space for the Department of Community Planning and Economic Development, among others. One of the features of the renovation by Architectural Alliance is an interior waterfall on one of the walls in the main lobby.

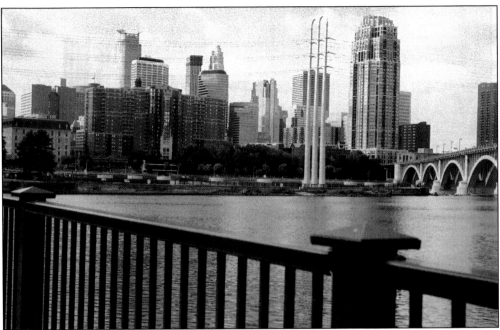

DOWNTOWN. The downtown area of Minneapolis, viewable on all sides from parks or parkways, has five elements—entertainment, business, medical, intellectual, and emerging upscale housing. This author may be biased, but there is no other downtown like it. Limited in geographic size by a freeway moat and the Mississippi River, it is lively at all hours. Its entertainment parts are the Target Center in the Hennepin Avenue district, the Metrodome, the convention center, Orchestra Hall, and Peavey Plaza areas. In between are offices, shopping, and the flow of 200,000 people. Intellectually, the new Minneapolis Public Library is on one side and the University of Saint Thomas on the other. The Hennepin County Medical Center is on the east side. In the middle is Macy's department store (before that Marshall Field's and Dayton's). Upscale housing is emerging along the periphery, especially near Loring Park and the river.

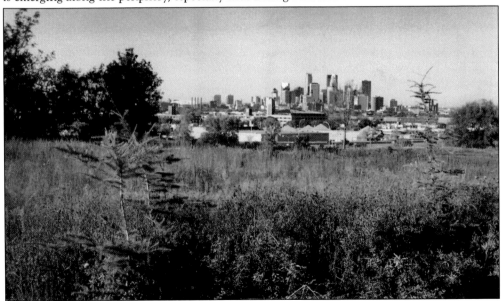

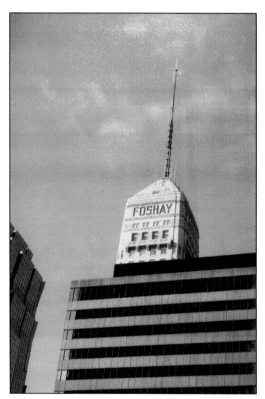

THE FOSHAY TOWER. At 400 feet and visible from most Minneapolis parks, the Foshay Tower was the king of the downtown skyline from the day it was built in 1929 to the day the IDS Tower was completed in 1973. John Phillips Sousa composed a special march for the grand opening of the building that was patterned after the Washington Monument. Architect Phillip Johnson's tower, twice the height of the Foshay, changed the size and scale of downtown office buildings. Now several reach, or nearly reach, its 800 feet. But none seem to have the discreet refinement or the public-space function of the seemingly uncovered Crystal Court where Mary Tyler Moore, riding the escalator, threw her hat. A new art deco–style skyscraper, designed by architect César Pelli of New Haven, Connecticut, was finally completed in 1989. One foot shorter (by design) than the IDS Tower, the new structure in stone contrasted with the glass-sheathed IDS and confirmed the size and scale of new downtown buildings of which there are now many.

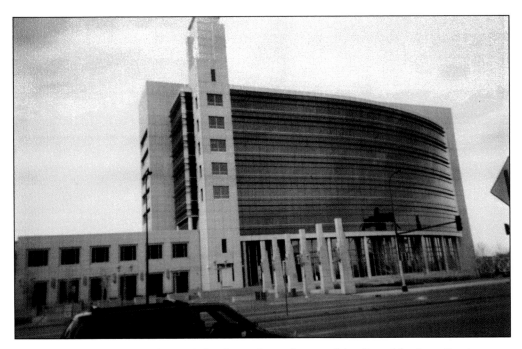

FEDERAL RESERVE BANK. The 1990s bank stands on the site of the Great Northern Station, torn down in 1978. Seeking a riverfront view and more space, the Federal Reserve Bank left its glass-walled, catenary-supported, Gunnar Birkerts–designed structure, built in the early 1970s at 250 Marquette Avenue, for a new structure designed by Hellmuth, Obata and Kassabaum of Kansas City. The Great Northern station, built in 1914 and designed by architect James Frost of Chicago, is remembered by a scale model at the Twin Cities Model Railroad Club in Saint Paul.

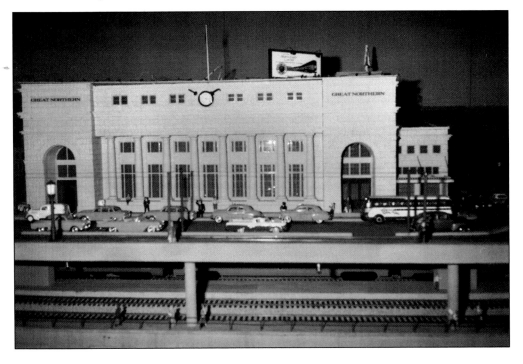

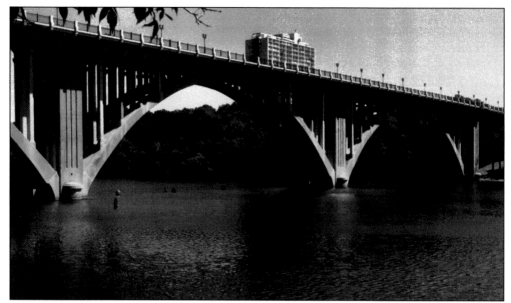

FORD BRIDGE. Built in 1927, this bridge with its sweeping concrete arches, designed by N. W. Elsberg, offers a magnificent view of the Mississippi Gorge. It also gives a close-up view of Lock and Dam No. 1, immediately downstream. The bridge was recently refurbished by the City of Saint Paul. It connects West River Parkway of Minneapolis and Saint Paul's Mississippi River Boulevard.

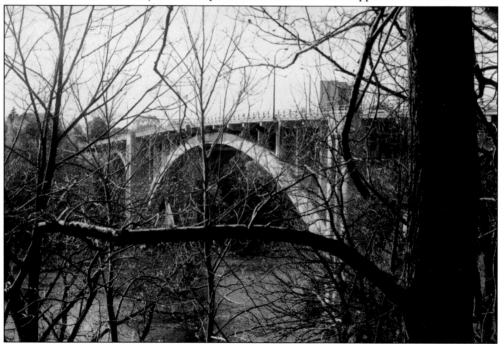

FRANKLIN AVENUE BRIDGE. Officially named the Cappelen Memorial Bridge, it carries the name of Frederick Cappelen who, along with Kristoffer Olsen Oustad, was its designer. Cappelen was also the Minneapolis city engineer. At 400 feet, the bridge was the world's longest concrete arch span when it was built in 1923. Only the foliage of the Mississippi Gorge and the adjoining I-94 crossing keep it from being fully appreciated.

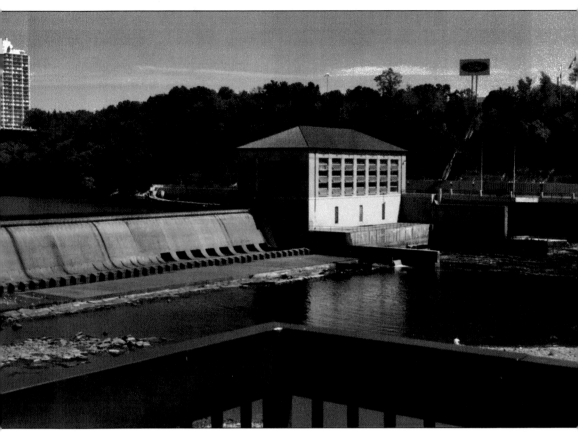

FORD HYDRO PLANT. Eighty-some years ago, the Ford Motor Company took a step towards becoming green, when it built its Twin City Assembly Plant. This hydro plant supplies electricity needed to produce Ford trucks in the upper Midwest.

FRUEN MILL. On the other side of Bassett's Creek is Wirth Park. The mill built between 1915 and 1928 is now vacant. It was the first gristmill powered by Bassett's Creek. Located at 301 Thomas Avenue North, one can stop, observe it, and take a trip back in time. With time travel set aside, William Fruen's real claim to fame may be the discovery of the spring nearby in Wirth Park, from which Glenwood Inglewood draws its bottled water.

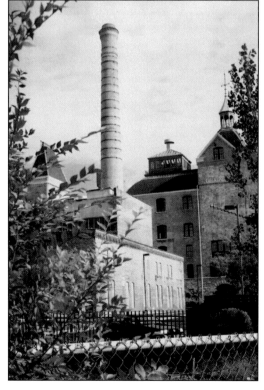

GRAIN BELT BREWERY. Like a castle on the Mississippi, this brewery has been a Minneapolis landmark since it was built in 1893. Architect Carl F. Struck's design was also the inspiration for the park shelters built nearly 100 years later at Boom Island. When the brewery operation stopped in 1975, this building at 1225 Marshall Street remained unused for several years. It has been renovated by the Department of Community Planning and Economic Development and is occupied by architectural offices.

GUTHRIE THEATER. This well-known repertory theater that bears the name of its theatrical creator, Sir Tyrone Guthrie, has always been a neighbor of the park system, first at The Parade and sculpture garden area and now on the Great River Road near the Mill Ruins Park. The original theater, designed by Ralph Rapson, head of architecture at the University of Minnesota, opened in 1963. With its thrust stage and creatively designed facade, this theater brought a distinctive new style of architecture to the Twin Cities. Architect Jean Nouvel of France introduced an entirely new structure in designing a much-needed larger facility with three types of stages, studio space, and support facilities. His design is reminiscent, in mass composition, of the old mill buildings in the district. It opened in September 2003. Lost was Rapson's original building when the Walker Art Center reclaimed the site. But both institutions now have much more copious facilities. (Below, courtesy Park Board.)

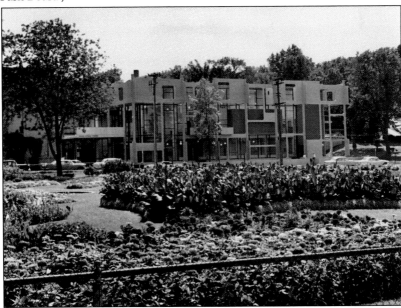

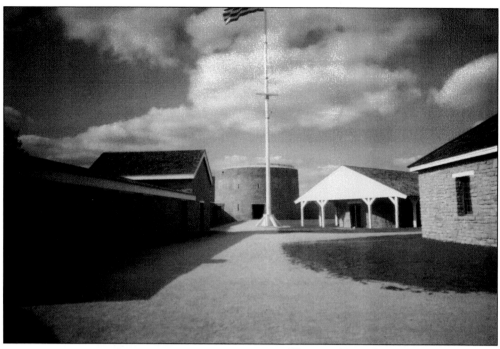

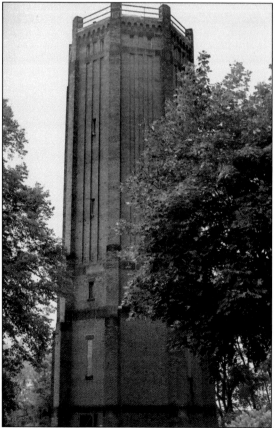

HISTORIC FORT SNELLING. Accessible by car from Minnesota Trunk Highways 5 and 55, or by foot or bicycle on a path along the Mississippi Gorge southbound from Minnehaha Park, this very early settlement on a high bluff at the confluence of the Minnesota and Mississippi Rivers is a treasure house of early structures. The fort, built by Col. Josiah Snelling and his troops from 1820 to 1825, was never attacked by any hostile forces, but it served as a springboard and a resource for early settlers. In the early 1960s, the Minnesota Historical Society restored the original fort as built by Colonel Snelling. There are many structures at the fort, the most notable of which is the restored round tower.

KENWOOD WATER TOWER. Though it is found at 1724 Kenwood Parkway, it looks like a medieval tower. Built in 1910 and designed by city engineer Frederick Cappelen, this tower stored water until 1954. It is now on the National Register of Historic Places.

HENNEPIN AVENUE BRIDGE DESIGN. It is possible that no other river has been crossed as many times at the same place as the Mississippi has at Hennepin Avenue. The first crossing, built in 1854, was a 620-foot-long wooden suspension bridge engineered by Thomas Griffith. It was built privately and later acquired by Hennepin County. Local historians purport it to be the first bridge crossing the Mississippi River. A second suspension bridge followed in 1876, also engineered by Thomas Griffith. Its span was 630 feet, and it had two 80-foot-high towers. A steel-arch bridge followed in 1889 and remained for 100 years. Many people were reluctant to see the steel-arch bridge go, when Hennepin County determined a new bridge with additional traffic lanes was needed. Only the landmark design of another suspension bridge, by Howard, Needles, Tammen, and Bergendoff, quieted those who wanted the old steel-arch bridge renovated. This suspension bridge, now an icon of the city, starred in the mid-1990s movie *Crossing the Bridge*. It played the role of the Ambassador Bridge between Detroit, Michigan, and Windsor, Ontario.

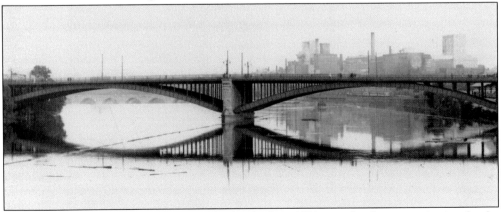

HENNEPIN AVENUE BRIDGE. This third bridge, built in 1889, was the design inspiration for the Irene Hixon Whitney Bridge between the Minneapolis Sculpture Garden and Loring Park.

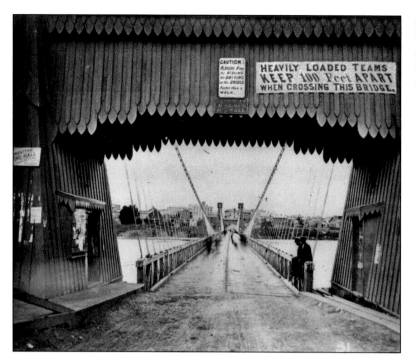

First Version. This is the first Hennepin Bridge, which was built in 1854.

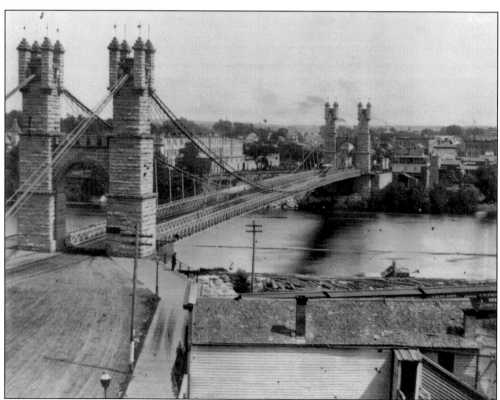

Second Version. This is the second Hennepin Bridge, which was built in 1876.

Minneapolis Waterworks. The land at the Minneapolis waterworks is considered part of North Mississippi Regional Park. Because of security reasons, people cannot access the property, but it provides substantial green space as part of the park. The handsome redbrick building framed here by the Camden Bridge is part of the waterworks plant.

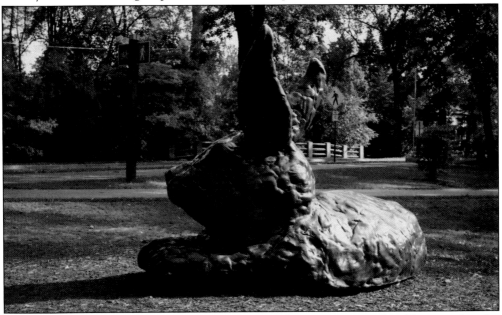

Park Bunny. Real rabbits abound in the park system but are not as comfortably situated as this large sculptured rabbit on East Minnehaha Parkway near Portland Avenue. Recently installed as part of the city's neighborhood Gateway projects, it is immensely popular. Where else can an adult sit on a bunny?

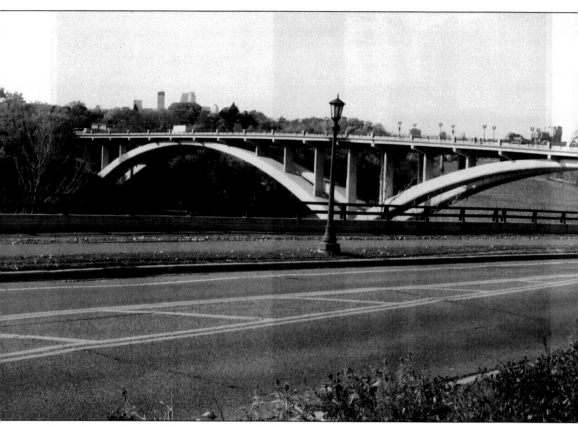

LAKE STREET BRIDGE. This concrete arch bridge, constructed in the late 1980s by C. S. McCrossen, gracefully crosses the river gorge. In doing so, it connects West River Parkway of Minneapolis to Saint Paul's Mississippi River Boulevard. When this bridge was constructed, West River Parkway was brought under the bridge with ramps up to Lake Street, a long-sought goal by the Park Board. Lost with this beautiful new bridge was the cheap thrill of feeling the old bridge sway and rattle as people crossed, suspended over the gorge during heavy traffic.

LOCK AND DAM NO. 1 VISITOR CENTER. This visitors center offers a lot of information on the lock and dam system of the Upper Mississippi River. From its viewing platform, one can watch a tow or several small boats lock through. Or looking upstream, a person can witness a great view of the river gorge through the arches of the Ford Bridge. Also in view is the hydropower facility for Ford's Twin City Assembly Plant. High above on the sandstone bluff is the Minnesota Veterans Home and the Wabun picnic area of Minnehaha Park.

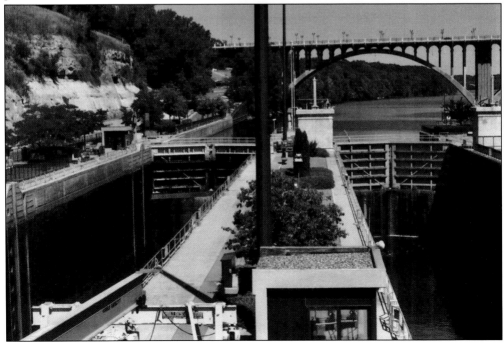

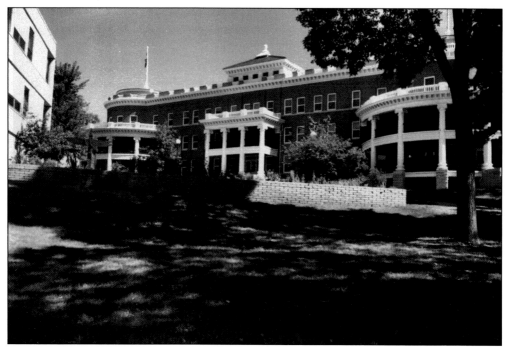

MINNESOTA VETERANS HOME. Land for the Minnesota Veterans Home was set aside in the late 1880s at the same time land was reserved for Minnehaha State Park. The two have been next-door neighbors ever since. This magnificent building, with its colonnaded solarium at either end, is an original that dates to a bygone architectural era of medical institutions. It was built around 1887 to 1892. Warren Dunnel is believed to be the architect. In the last 15 years, the veterans home has been constructing new buildings and renovating older ones, but none compare to this.

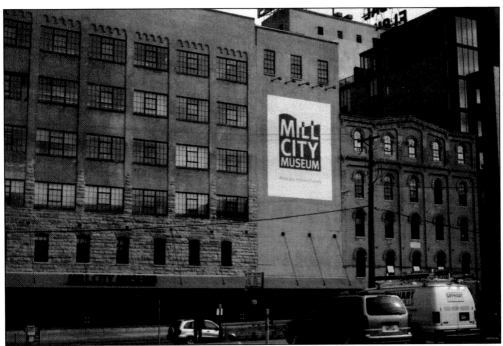

MILL CITY MUSEUM. Nothing says it all quite like the Mill City Museum. The museum culminates the efforts of the Minnesota Historical Society and the Saint Anthony Falls Heritage Board to interpret, in a first-class manner, the Saint Anthony Falls area. The museum is in the Washburn-Crosby milling complex—principally in the "A" mill. It is built in the structure designed by Adolph Fischer and William de la Barre in 1880. The first Washburn-Crosby "A" mill, constructed in 1874, was totally destroyed by explosions and fire on May 2, 1878. Even the 1880 structure had its catastrophe in the fire of 1929. Again rebuilt, the mill operated until 1965.

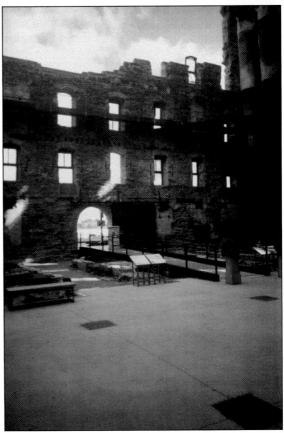

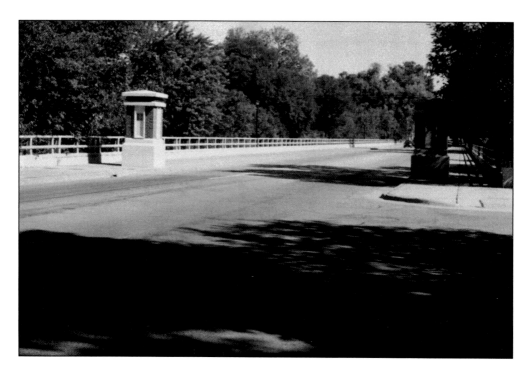

NICOLLET AVENUE BRIDGE OVER MINNEHAHA CREEK. Except for its recently constructed brick pylons and new lighting, one might easily drive over this bridge and not notice it. Likewise, its graceful concrete arches somehow make it fitting and unobtrusive as it crosses the Minnehaha Creek valley. Built in 1923, it was designed by engineers Kristoffer Olsen Oustad and N. W. Eisberg.

NE COMMUNITY LUTHERAN CHURCH.
"NE" does not stand for New England,
but Northeast Minneapolis. Many
churches in Minneapolis neighbor
parks or parkways. But this one, built
in 1883, is particularly striking with
Logan Park's trees in the foreground.

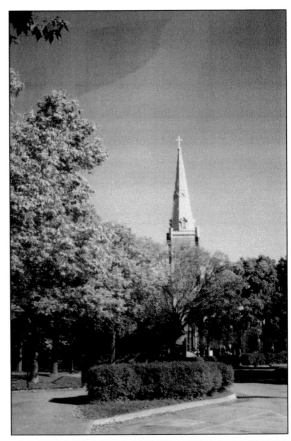

**ING BUILDING, FORMERLY THE
NORTHWESTERN NATIONAL LIFE
INSURANCE COMPANY.** Built in
1965, at 20 Washington Avenue, this
contemporary structure designed
by Minoru Yamasaki of Detroit was
one of the earlier edifices in the
Washington Avenue Gateway urban
renewal area. Its portico leaves the
extension of Nicollet Avenue to
Hennepin Avenue visually open,
but it makes Gateway Park look
like its front yard. Forty-some years
later, it is still a gleaming example
of the hopes of postwar America.

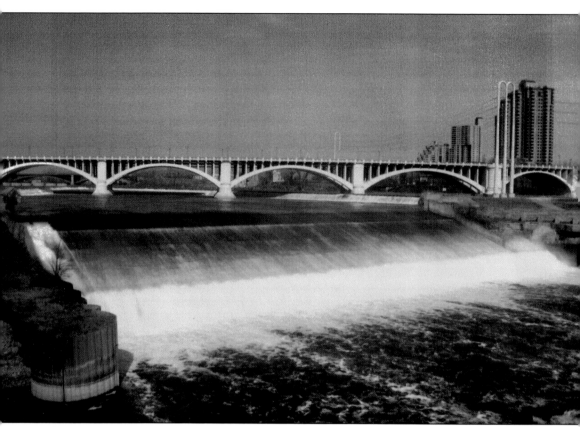

THE FALLS OF SAINT ANTHONY. The Falls of Saint Anthony looked far different 140 years ago. They were very steep rapids when Mother Nature was the architect. Fearful that the cataract would self-erode, a concrete apron was planned to preserve the falls. J. T. Stevens of Lewiston, Maine, was hired to supervise construction. But work was more than interrupted when the construction of the Eastman Tunnel, under Hennepin and Nicollet Islands, collapsed, threatening the entire area. After the tunnel collapse subsided, J. T. Francis, an engineer from Lowell, Massachusetts, recommended work on the apron be restarted and the collapsed tunnel be sealed. With Stevens again supervising the construction, work was completed in November 1870. Whether it is heavenly influence, Francis's engineering, or Stevens's construction, the Falls of Saint Anthony are the centerpiece of Minneapolis's riverfront park and its riverfront redevelopment. (Photograph by Nancy Conroy for the Park Board.)

PILLSBURY "A" MILL. This mill did not totally cease operations until just a few years ago. The appearance of the magnificent industrial structure, which towers over Hennepin Bluffs Park, defies its 127 years. Designed by architect L. S. Buffington and milling engineer W. F. Gunn, it does credit to the long-established family whose name it carries.

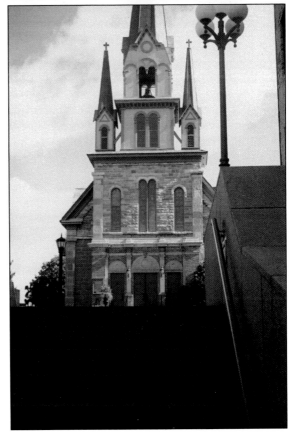

OUR LADY OF LOURDES CHURCH. This view of the old French church, at 21 Prince Street, could save one a trip to France. It is believed to be the oldest church of continuous use in Minneapolis. Originally built in 1857 in a Greek Revival style, it was the first Univeralist meetinghouse. In the 1880s, it was acquired by French Catholics who added the steeple and rear transom, giving it an added blend of French Second Empire architecture. The church's records of baptisms, weddings, and so on are like a mini history book of the area—particularly for those of French descent.

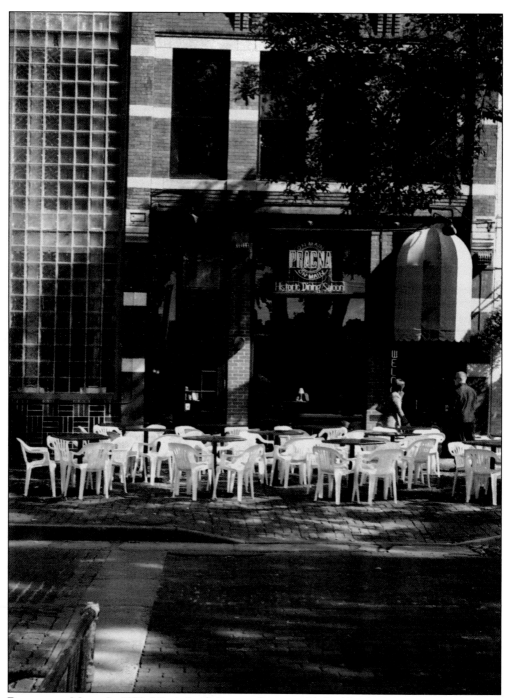

PRACNA ON MAIN. In 1972, *Mississippi/Minneapolis* was published by the Minneapolis Planning Commission, containing plans and sketches for the redevelopment of the Minneapolis riverfront. Pracna on Main became one of the realities of that report. Its renovation, by architect Peter Hall, was in process at the time. Designed originally in 1890 by architect Carl F. Struck, this restaurant at 117 Main Street SE stands out as the beacon of the whole revitalization of the Minneapolis riverfront.

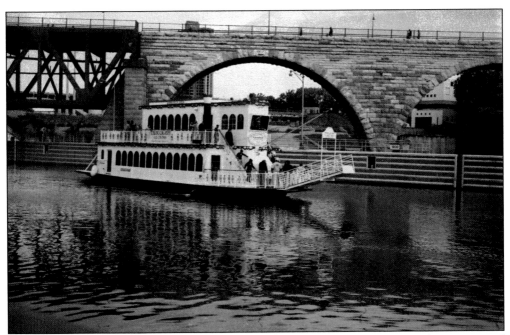

RIVERBOATS. An 11-foot-deep channel is maintained on the Mississippi River for commercial navigation up to the Camden Bridge. Naval architecture on the Mississippi comes in three forms: towboats, barges, and excursion boats. To get to the upper harbor of Minneapolis, towboats and excursion boats must be designed to pass under the low clearance of some of the bridges downtown. Tows have been going to the upper harbor since the 1960s, when the Saint Anthony Locks were built. Prior to that, they went no farther than the Washington Avenue Bridge. Minneapolis has had excursion boats since the Boom Island landing was built in the late 1980s.

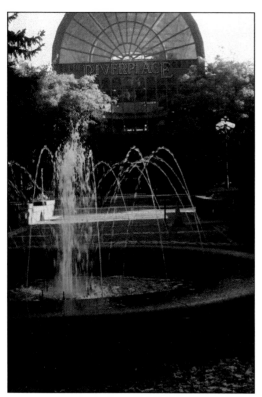

RIVERPLACE AND SAINT ANTHONY MAIN.
The Boisclair Corporation, the Zelle
Corporation, and others followed quickly to
bring much of the plans and sketches to life
after *Mississippi/Minneapolis* was published
by the city planning commission in 1972.
Built between 1975 and 1985 in the vicinity
of Main Street SE and Second Street SE,
the development had the first festival
market in the Twin Cities. Every effort
was made to bring one-of-a-kind stores
into the complex. Although the shopping
aspects failed, the offices and restaurants
did not. With an estimated 1.6 million
park visits per year, the ambiance along
the river, the Stone Arch Bridge, Nicollet
Island, and private development went well
beyond the far-reaching visions portrayed
in the *Mississippi/Minneapolis* report.

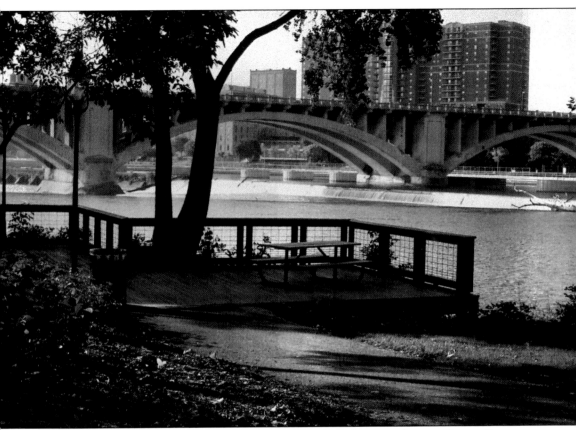

THIRD AVENUE BRIDGE. This low-profile concrete arch span with a somewhat curvilinear alignment was built in 1918. With its series of short arches, it looks almost like a white caterpillar stretching across the Mississippi.

UPPER SAINT ANTHONY FALLS VISITORS CENTER. The address 1 Portland Avenue is appropriate for this uppermost lock on the Mississippi. Each year, 50,000 people take advantage of its indoor viewing of Saint Anthony Falls and the chance to see a tow lock through. It is industrial architecture as well as Army Corps of Engineers architecture. It bespeaks no-nonsense function with a decor straight out of the manual. Nonetheless, it offers information on the construction and operation of the locks and the navigational function of the Mississippi River system—all at no cost to the visitor.

PARK AND PARKWAY HOUSES. The parkways and streets around city parks and lakes have an array of houses and high-rises; the designs include Greek Revival, Tudor, Colonial, modern, contemporary, postmodern, and eclectic.

MORE PARK AND PARKWAY HOUSES.
These pages are presented to give
a glimpse of noteworthy houses
without disturbing the privacy of the
occupants. Homes that are part of
the area include the house of a citizen
who worked tirelessly to save the city
from the ravages of Dutch elm disease,
the house of a former Mobile Army
Surgical Hospital (MASH) nurse who
spent a career in the public-health
sector, and the house of the president
of the Minneapolis City Council.

SAINT MARK'S EPISCOPAL CATHEDRAL. The Episcopalians beat the Catholics by four years in erecting their cathedral in the Hennepin/Lyndale, Loring Park area. This church at 519 Oak Grove Street anchors well the southeast quadrant of this cultural locale. Designed by Edwin Hewitt and built in 1911, it has been the spiritual home for many of the most prominent citizens of Minneapolis, including Sir Tyrone Guthrie.

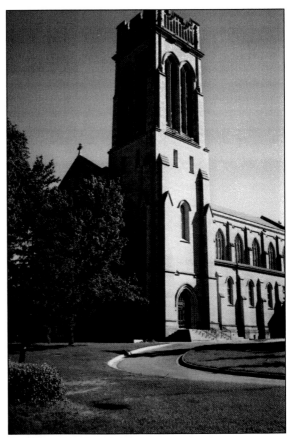

SOUTHEAST STEAM PLANT. Built in 1904, this brick structure with multistory glass windows had supplied power for Twin Cities streetcars for half a century. In 1954, the plant was sold to the Northern States Power Company. NSP converted it to oil and 22 years later sold it to the University of Minnesota. The university converted it back to coal with an oil option.

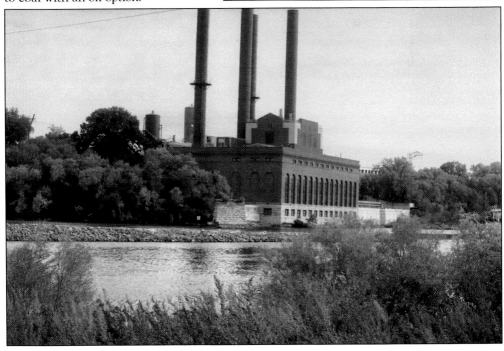

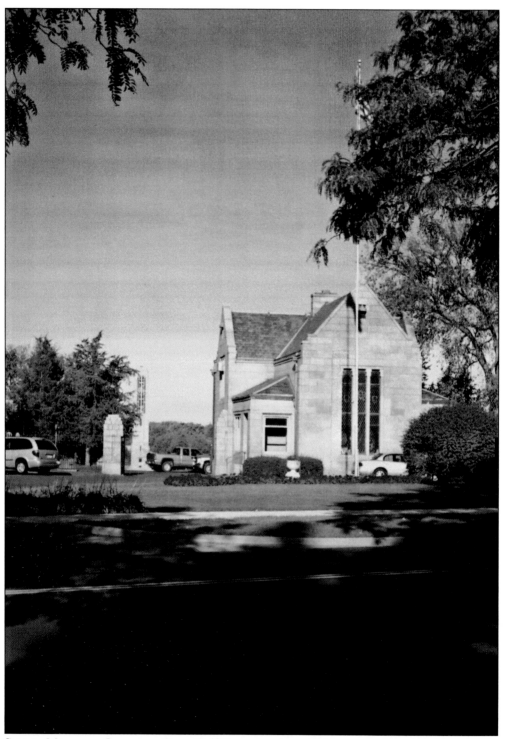

SUNSET MEMORIAL CEMETERY. Gross Golf Course's quiet neighbor across the street offers its own piece of architecture to the Saint Anthony Parkway scene. Built in 1927, this chapel by Lovell and Lovell offers a somewhat 1920s version of Gothic Surreal.

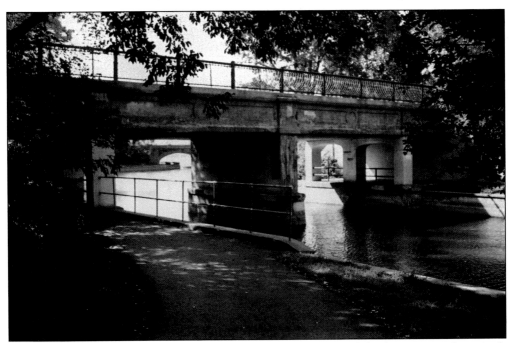

MIDTOWN GREENWAY. Possibly no other city has an exclusive bicycle/pedestrian way that travels its width. Using an old, below-grade rail line that was bridged by every avenue crossing it, the City of Minneapolis constructed the Midtown Greenway. The shorter of the two bridges shown carries the paths across the channel that connects Lake Calhoun with Lake of the Isles. The long, high bridge, owned by Canadian Pacific Railway, will eventually carry bicyclists and walkers over the Mississippi River to the University of Minnesota. This is quite a change for a corridor once planned to be an expressway.

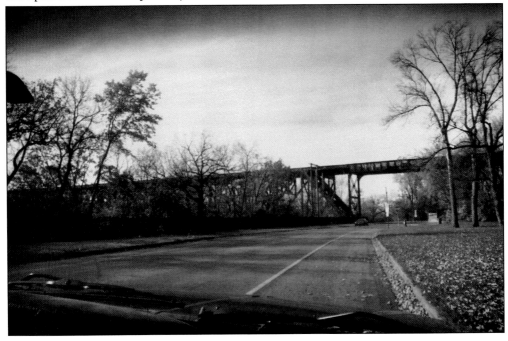

UNIVERSITY OF MINNESOTA. Almost everyone visiting or convening in Minneapolis wants to see the university. It is the place of legends like John Najarian. The university is shown as seen from West River Parkway. Established in 1851, it has been faithfully following the vision of William Watts Folwell, its first president.

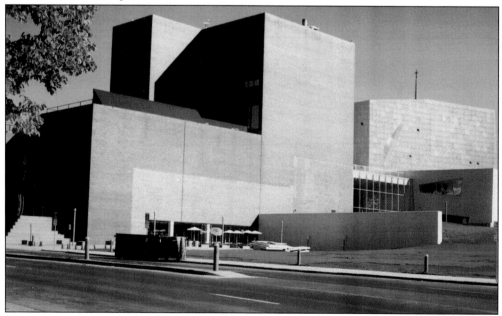

WALKER ART CENTER. Legend has it that when Minneapolis lumberman T. B. Walker could not find a home for his personal art collection at the Minneapolis Institute of Art he started his own museum; first in the mansion he purchased from Thomas Lowry in 1927 and then in the museum he built next to his house. A building designed by Edward Larrabee Barnes was constructed in 1971 on the site. Jacques Herzog and Pierre de Meuron designed the 2005 addition.

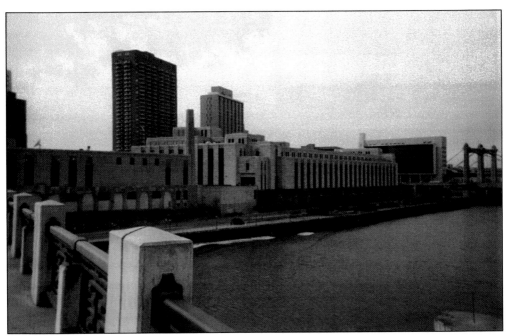

U.S. Post Office. Architects Magney and Tusler made their mark on downtown at least twice; first the Foshay Tower and then the post office. This post office serves the Twin Cities metropolitan area and beyond. Mail comes from all over the world, and it is distributed out of this regional facility just as checks do upriver at the Federal Reserve Bank. The building's art deco federalist style is classic of the early 1930s, when it was built. Its very long marble lobby is well known. What is not well known is its employee cafeteria on the fourth floor that has an expansive view of the Mississippi.

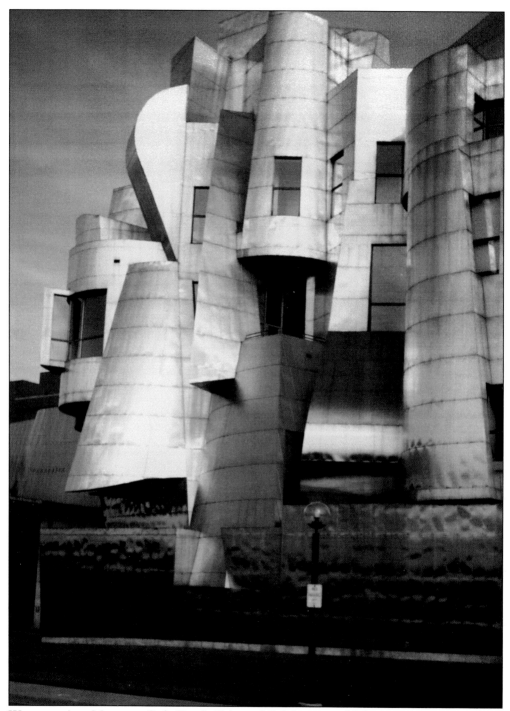

WEISMAN ART MUSEUM. Only Frank Gehry of California could design a museum in shiny metal with the look of squashed tin cans. Backside and inside, the museum looks and feels quite conventional, but the facade facing the Mississippi River at 333 East River Parkway is pure Gehry. Constructed in 1993, it is a radical departure from other University of Minnesota buildings, but no one can say the university turned its back on the river.

Four

BLUE TREASURES

SOMETHING BLUE. Only the Lake Harriet pavilion area qualifies as something blue. It has the only structures in the park system known to be painted that color. The bandstand, when built in 1986, was originally painted a blue gray. Its companion piece, the Lake Harriet Refectory, built in 1990, was also painted blue gray. Milo Thompson, the architect for both structures, said their shingles would weather blue-gray naturally. The bandstand became an icon of the city, appearing on phone books, postcards, and many other pieces. It was built to replace the temporary bandstand completed in 1927, which replaced two previous ones. Outdoor music has been a feature at Lake Harriet since 1888, when the Twin City Lines wanted to attract riders to the end of their Como-Harriet line. The site is prone to tornados and high winds, which partially explains why there have been so many bandstands. However, the popularity of the location outweighed any thought of changing sites.

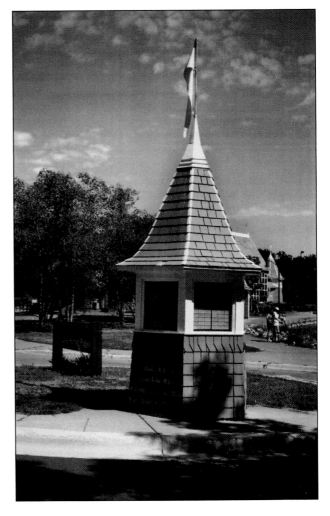

121

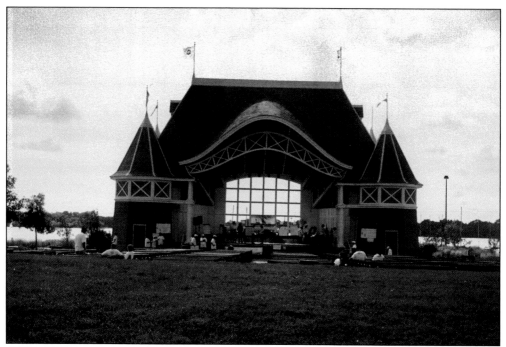

A Blue Treasure. This blue treasure was the cause of a surprise for a park staff person who received a call from a British filmmaker. The producer was urged by Prince Charles to investigate the bandstand as a possible locale for a movie setting. The prince had been the awards presenter for the American Institute of Architects and remembered the bandstand as a recipient.

Comfort Station Design. Architect Harry Jones's women's comfort station was the design inspiration for the current bandstand and refectory. The station has been refurbished and is in use.

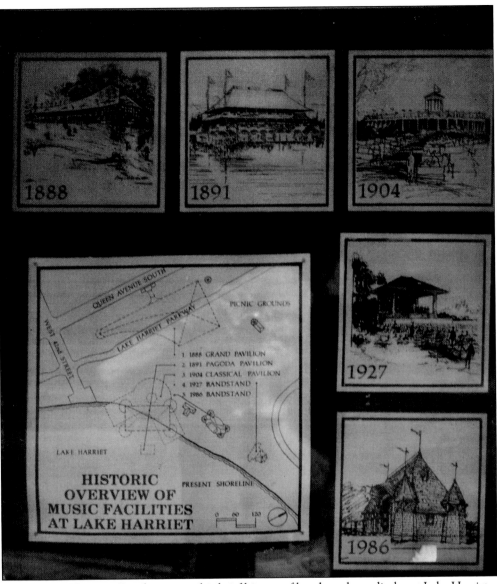

BANDSTAND HISTORY. People can see this brief history of bandstands on display at Lake Harriet.

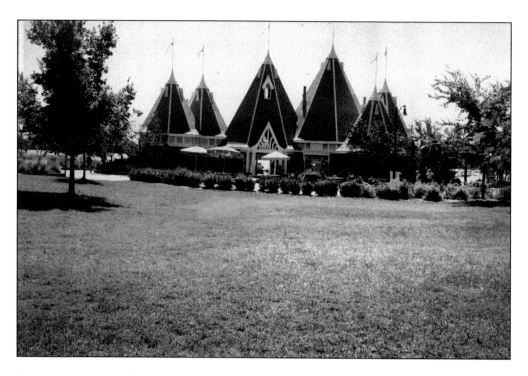

REFECTORY. Looking like a renaissance fair, the current refectory and toilet building stands as the companion piece to the bandstand. The building below, constructed in 1927, served as the refectory until it was replaced in 1990. (Below, courtesy Park Board.)

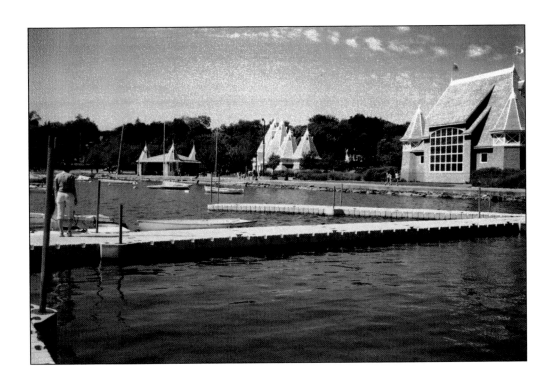

NORTH SHORE. These legends in blue (or tan) grace the north shore of Lake Harriet, providing either good music, or good ice cream, or both.

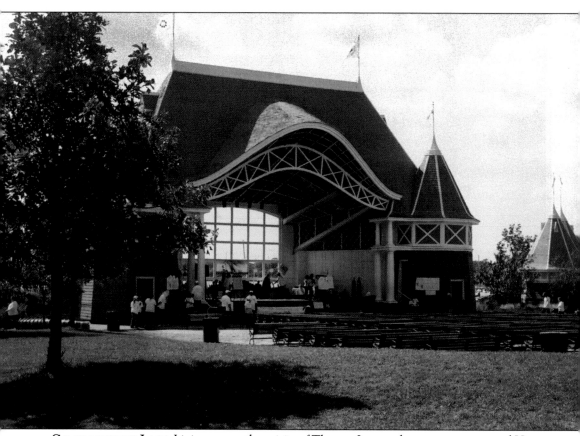

CAMELOT BY THE LAKE. Living on are the spirits of Thomas Lowry, the streetcar man, and Harry W. Jones, park commissioner and architect extraordinaire. Lowry is the man whose company started the tradition of music and dining at Lake Harriet 120 years ago, and it is Jones's building that still stands as the design inspiration for Camelot by the Lake.

BIBLIOGRAPHY

Gebhard, David, and Tom Martinson. *A Guide to the Architecture of Minnesota*. St. Paul, MN: University of Minnesota Press and the Minnesota Society of Architects, 1991.

Hess, Jeffrey A., MacDonald and Mack Partnership, and Miller Dunwiddie Architects, Inc. *St. Anthony Falls Rediscovered*. Minneapolis: Minneapolis Riverfront Coordination Board, 1980.

Kane, Lucile M. *The Waterfall that Built a City*. St. Paul, MN: Minnesota Historical Society, 1966.

Lanegran, David A., and Ernest R. Sandeen. *The Lake District of Minneapolis: A History of the Calhoun-Isles Community*. Minneapolis: University of Minnesota Press, 2004.

Millett, Larry. *AIA Guide to the Twin Cities*. St. Paul, MN: Minnesota Historical Society Press, 2007.

———. *Twin Cities, Then and Now*. St. Paul, MN: Minnesota Historical Society, 1996.

Wirth, Theodore. *Minneapolis Park System, 1883–1944*. Minneapolis: 1945.

www.arcadiapublishing.com

MAP SEARCH

Discover books about the town where you grew up, the cities where your friends and families live, the town where your parents met, or even that retirement spot you've been dreaming about. Our Web site provides history lovers with exclusive deals, advanced notification about new titles, e-mail alerts of author events, and much more.

MADE IN THE USA

Arcadia Publishing, the leading local history publisher in the United States, is committed to making history accessible and meaningful through publishing books that celebrate and preserve the heritage of America's people and places. Consistent with our mission to preserve history on a local level, this book was printed in South Carolina on American-made paper and manufactured entirely in the United States.

This book carries the accredited Forest Stewardship Council (FSC) label and is printed on 100 percent FSC-certified paper. Products carrying the FSC label are independently certified to assure consumers that they come from forests that are managed to meet the social, economic, and ecological needs of present and future generations.

FSC
Mixed Sources
Product group from well-managed forests and other controlled sources

Cert no. SW-COC-001530
www.fsc.org
© 1996 Forest Stewardship Council

Find Your Place in History.